STORIES IN STONE FROM
THE ROMAN FORUM

BY

ISABEL LOVELL

ILLUSTRATED

New York
THE MACMILLAN COMPANY
LONDON: MACMILLAN AND CO., Ltd.
1904

STORIES IN STONE FROM THE
ROMAN FORUM

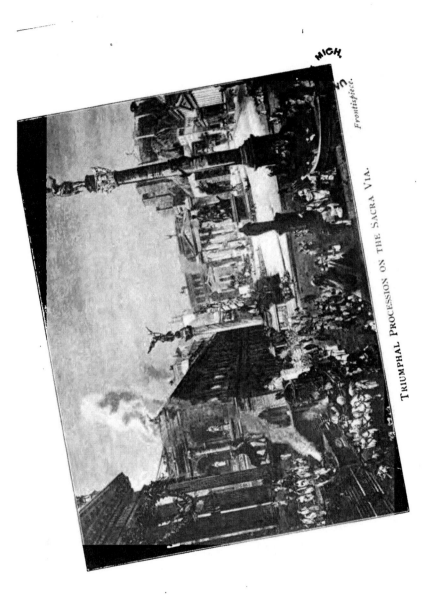

TRIUMPHAL PROCESSION ON THE SACRA VIA.

Norwood Press
J. S. Cushing & Co. — Berwick & Smith Co.
Norwood, Mass., U.S.A.

PREFACE

To tell "why," simply and clearly, is the exceedingly ambitious aim of this book. Not "how," which is the archæologist's affair, but "why," — why the Forum of Rome became the centre of the nation's life, why the Romans wore white togas, why the public Treasury was under Saturn's charge, why the basilicas were built, why the donkeys were decked with cakes during Vesta's festival, why the temples stood on high foundations, why the magnificent monuments crumbled into ruins, and many other "whys" that travellers wish to know, that historical readers seek, that young students enjoy. The stories are but retold, the facts restated, but no legend is narrated, no statement made, that is unvouched for by a recognized authority. It may be added that the illustrations have been inserted more as aids to the imagination than as material for scientific study.

New York,
September, 1902.

CONTENTS

▼

ILLUSTRATIONS

AUTHORITIES

DIONYSIUS OF HALICARNASSUS.
TITUS LIVIUS.
P. OVIDIUS NASO.
PLAUTUS.
M. VALERIUS MARTIALIS.
SEXTUS AURELIUS PROPERTIUS.
C. CORNELIUS TACITUS.
PLUTARCH.
C. SUETONIUS TRANQUILLUS.
M. FABIUS QUINTILIANUS.
M. TULLIUS CICERO.
APPIANUS.
DION CASSIUS COCCEIANUS.
C. SALLUSTIUS CRISPUS.
PLINY THE ELDER.
PLINY THE YOUNGER.
PUBLIUS VIRGILIUS.
FLAVIUS JOSEPHUS.
MOMMSEN.
HENRY THEDENAT.
ORAZIO MARUCCHI.
GASTON BOISSIER.
RODOLFO LANCIANI.
J. HENRY MIDDLETON.
FRANCIS MORGAN NICHOLS.
H. JORDAN.
W. IHNE.
E. GIBBON.
W. ADAMS.
L. PRELLER.
ENCYCLOPÆDIAS AND CLASSI-
CAL DICTIONARIES.

STORIES IN STONE FROM THE ROMAN FORUM

I

THE STORY OF THE FORUM ITSELF

THIS is a story about a "place out of doors," for that is what "forum" means. It is a story in stone, told by the buildings and monuments of the great Forum of Rome, one of the most interesting places in all the world. And the story tells, not only of the making of the Forum, but of the many things that happened there, and from it we learn of a people strong and warlike, of a nation of conquerors and lawgivers, who became the masters of the ancient world.

This Forum was the place out of doors of which the people were most fond and proud, and, like the forums of other Roman towns, it was an open, oblong space through which passed several

narrow roads, and in and round which were many of the principal buildings of the city. It was used for many purposes — as a market-place, where all kinds of things were bought and sold, from a sack of meal to a necklace of finest gold; as a court of law, where men were tried and judged, from the pickpocket to the traitor of his country; as a meeting-place, where friends came together, both the common citizens and the men of high degree; and as a place of entertainment, where the people amused themselves with games, and where feasts were given in honour of great events, such as the birthday of an emperor, or the triumph of a victorious general.

Although it became much more important, the Forum took the place of the central square, or green, or common, of one of our small towns. To such an open space the people go to meet each other, to listen to public speeches, to rally in times of war, or to buy and to sell; and here are found such buildings as the shops, the court-house, the theatre, or the churches.

But the Roman shops were not like our shops, which are parts of houses, or are great buildings in themselves; they were more like booths, with

2

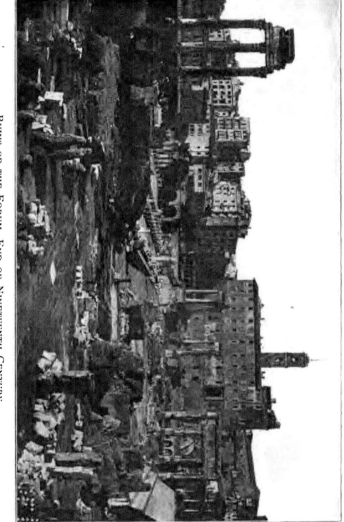

RUINS OF THE FORUM, END OF NINETEENTH CENTURY.

fronts entirely open, and with the wares shown
on low counters, so that every one who went by
could easily see and examine what was offered
for sale. Behind the counter sat the merchant,
greeting any friend who happened to pass that
way, bargaining with persons who stopped to
buy, and perhaps inviting good customers inside
to show them some rare and costly thing. There
were two rows of such shops in the Forum, one
on the north, the other on the south side. Among
them were the public schools for children, and
here, after the manner of those days, the youths
and maidens learned to write on tablets of wood;
on these, with a small, pencil-like stick called a
stilus, they traced the tasks set by their teachers.
They also learned to recite poems about the
brave heroes of their country, to do simple sums,
and to repeat those laws that in Rome were
always taught the children. Many of the shops
were those of jewellers and silversmiths, whose
beautiful wares were shown in place of the meat,
the fish, and the vegetables of the humble market-
men who, as the Forum became more important,
moved into the back streets of the city. Rome
being in a warm country, much of the business

3

was done out of doors, and many things were sold in the Forum by men who, with stands or baskets, stood about the corners of the buildings and cried out their goods, much as is done on our streets to-day; still other venders had their places in the porticos of the Forum's great basilicas.

Now these basilicas were the Roman courts of law, but were different from our court-houses, for besides having a great hall in the middle of the building, where the trials were carried on, they were made with wide, shady porticos. These were so large that the quiet of the court room was undisturbed by the noise of the crowds outside, where the people were walking up and down among the marble pillars, gossiping together, bargaining with the money-changers, or playing games of chance, for the Romans were very fond of gambling.

But there were no theatres like ours in the Roman Forum, although plays were sometimes given there. At such times the people, in gay holiday dress, sat on rows of wooden benches which, whenever the shows took place, were put up round the centre of the Forum, where the

4

acting was all done in the open air. Some of the citizens looked on from the upper stories of the shops and basilicas, while a few very wealthy and honourable families sat in balconies round columns, placed in the Forum to the memory of some of their famous ancestors.

And the plays themselves were not like our plays, for the actors wore large masks — a crying face if the part was sad, a laughing face if the part was gay — and spoke long poems, and made many gestures. Besides the plays, games were often given in the Forum, and these again were different from our games, for although the Romans had of course games for children, and sports simply for amusement and to show skill and strength, when they spoke of a "game," or "the games," they meant not only a contest of some sort, but a part of a great religious ceremony or festival. These games were of many kinds, but only two sorts were given in the Forum — fights between wild beasts, and combats between men called gladiators who, skilled in the use of various weapons, fought in pairs against each other until one of them was killed. When these gladiatorial shows were given in the Forum they

5

also, like the plays, took place in the centre, and the people watched them with even more interest than they did the actors, for these contests were the favourite amusement of the Romans. But one thing about the fights of the gladiators seems even stranger than the fact that men, and women, too, enjoyed looking upon their fellows as they strove to kill each other, and that is, that these gladiators were hired to fight at funerals. For the Romans believed that the spirits of their ancestors were fond of blood, and that if much of it was spilled round the pyre on which a body was burned, the soul of the dead would be safe and happy. So the gladiators were hired to fight there; and the richer the family of the person who died, the greater the number of them employed in these contests, which all the people of Rome came to watch.

The churches of the Romans, too, were not like our churches, for they had no bells or spires, no seats or galleries, no organs or pulpits. The buildings, called temples, in which they worshipped, had flat roofs, or sometimes none at all; and the people never sat, but stood or knelt before the image of the god, or gods, to whom

the temples were built. The priests preached no sermons, but, amid chants and solemn prayers, burned incense and offered sacrifices on the altars. For these temples were sacred, not to the one True God, but to one or more of the many gods whom the Romans worshipped, and to whose honour they placed in the Forum many of these beautiful buildings.

But although many of the ways of the Romans were not like our ways, there was much about their life that was not so very different from ours of to-day; for, after their own manner, as we have seen, they traded with one another in the shops, tried and sentenced men in the court-houses, came in gayly dressed crowds to the plays and entertainments, and worshipped in the temples, just as in this country, after our manner, we do the same sort of things to-day.

Then why was the Forum of Rome so different from other places? Why was it so important?

The Forum was so different, because it contained a greater number of beautiful buildings and monuments, placed there for more purposes and uses, than any other place of its size and kind in all the world. For although it was not much wider or

7

longer than one of our city blocks, as we see them bounded by four streets, there were on the Forum the Senate-house, the Prison, the Tabularium, or record building, the Rostra, or platform from which the orators spoke; also temples, and basilicas, and statues, and triumphal arches, and columns raised in honour of famous men, or great national events. And each building, each monument, told its story, a story in stone.

And the Forum was so important, because these stories give us the history of the Roman nation, which is that of a city, not of a country; for, however far the all-conquering Romans went, it was always for Rome that they fought, always to Rome that they returned — to Rome, whose praise or blame made or marred a Roman's life — to Rome, the beginning and the end of all things to her people.

So the Forum and the Nation grew in importance together, for the Forum was the centre of the City, and the City was the centre of the Nation. When the Nation was small, and the people were simple in their ways, there were only a few plain buildings in the Forum; but when the Nation was large, and the people rich and

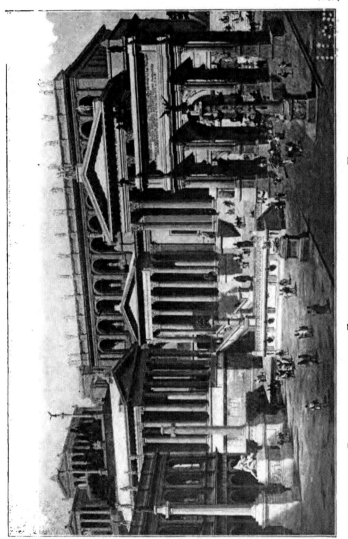

RESTORATION OF THE FORUM, LOOKING TOWARD THE TABULARIUM.

learned, the buildings crowded one upon another, and were as beautiful as men could make them. But even when most crowded with monuments, the Forum never became larger in size, and this was because it was measured, not by a foot-rule, but by the human voice — it was as large as a man's voice could carry, and no larger. For there were no newspapers in those days, nor was there any telegraph. All things of interest to the people were told them by the criers or orators, according to the importance of what was said; and the Forum had, therefore, to be large enough to hold the people of Rome, yet small enough for a man's voice to be heard throughout its limits. It was here that every one came for news, — to know of the latest movements of the army, to learn the result of some election, to hear who won at the races, or to listen to the announcement of some new play. But more stirring than anything ever spoken there, is the story of the Forum itself, a story in four parts, the same into which the history of ancient Rome is divided: the very early times, the times of the Kings, the times of the Republic, the times of the Empire.

In the very early times, the ground on which

the Forum now stands was but a marsh in a
valley among some green hills, the seven famous
hills on which the city of Rome was afterward
built. Near the centre of this marsh was a
hollow into which trickled the waters from the
springs of the hills above, forming a deep pool,
or little lake, around which grew bulrushes and
other reeds. Here and there, too, were other
pools, and along the valley ran a river called the
Tiber, into which emptied a small brook, called
the Spinon, and both brook and river often over-
flowed their banks. So the land was swampy and
unfit to build upon, and was used as a pasture for
the cattle and the sheep. But at its upper end,
at the foot of the hill called the Capitoline, was
some higher ground where the people of the
valley met to buy and sell the simple things
needed for their daily life. Some of them were
fishermen, who gave their catches for the game
the hunters had killed in the forests; and some
were makers of bows and spears, who offered
their weapons for the sheep the shepherds had
chosen from their flocks; others brought furs and
skins, others came with meal or fruit, and yet others
sold vessels of clay — pots, and plates, and

pitchers. All the things in this market of the very early times were most plain and simple, but the day came when the best and the finest that the world could offer was placed there on sale, for it was on this spot that, many years later, the great business of the Roman Forum was carried on.

In one of the huts of the market-place a fire was always kept burning, and was tended by the young maidens of the village, who had it in their special care, while their fathers and brothers hunted or were at war, and while their mothers worked in the home, or wove stuffs for their simple clothing. It was hard to get fire in those early days, when it was done by striking sparks from wood or stone, and therefore from this hearth of the people brands were taken to light the home-fires, from which each household received warmth, and by which the daily meals were cooked.

The people of those early days lived in small huts thatched with straw, and busied themselves in raising cattle, and in working in the fields. Therefore the first altar in the market-place was one to Saturn, the god of Agriculture, who holds

11

the sickle in his hand, who watches over the seed-time and the harvest, and to whom the market-days were sacred. This altar, on which the people offered sacrifices of cakes of salted meal, that their crops might be successful, was probably only a rough block of stone, as were the few other altars and shrines that were placed there in honour of some of the other gods.

Now we are told that, in those far-off times when men believed that the greatest among them were descended from the gods, and that sturdy heroes sprang from the hearts of oaks, the good Evander ruled with justice over his people among those peaceful hills. And they say that one fair day he, his son Pallas, and his warrior chiefs, were making a solemn feast to Hercules, in a grove not far beyond their simple homes, and that the sacrifice had just been killed, when two ships, bearing men in shining armour, were seen nearing the banks of the Tiber before them. Then suddenly the worship ceased, all hearts beating with the fear of coming evil, and none moved save Pallas who, bold with youthful courage, ran forward to the nearer vessel, calling out to the chieftain, standing calmly at the prow:—

"Come ye in peace or war?"

In reply, the noble stranger held out an olive branch, and, stepping from the ship, asked to be led before Evander, to whom he told his errand and his name, saying that he was Æneas, exiled from Troy, and in need of arms to battle for his rights.

Good Evander gave him gracious welcome, and caused him to rest upon a couch covered with a lion's shaggy skin, and, when the holy rites were ended, offered refreshment to the royal stranger and his followers. Then, as the twilight was come, he took the arm of his guest, and that of Pallas, his son, and led the way through the wood to his home at the foot of one of the seven hills, and, as they walked, he told the simple history of his people, and the stories of the places round about.

And so they reached Evander's home, before the door of which were cattle feeding on the grass of the plain, just where, years after, hurrying multitudes passed to and fro in the business of a great city's life. Of this the poet Virgil tells when he says, —

13

"In talk like this Evander's modest home
They reach, while here before their eyes
Are cattle bellowing, where anon shall stand
The Roman Forum, and Rome's proudest street."

When the next day came, Æneas, refreshed and brave at heart, bade his gracious host farewell, and, accompanied by Pallas, at the head of many warriors, went forth to fight his battles, and to win his cause.

. Since those very early times, many travellers have journeyed to this valley of the seven hills, and have stood upon the ground where once the cattle were pastured, and where later the great Roman Forum was built; but the first visitor whose foot crossed this famous place was Æneas of Troy, guest of the good Evander.

After many wanderings and many adventures, the days of the noble Æneas came to an end, and, when the time of the kings had come, Romulus, his strong and valiant descendant, was the first to rule over Rome — for so was called the city that he founded on the Palatine, one of the seven hills. And with his reign came changes to that peaceful valley, for Romulus waged many wars with the people round about,

14

and when history first speaks of the Roman Forum it is to tell us of a fierce battle, fought there between the Romans and the Sabines, a neighbouring tribe ruled over by Tatius, their warlike king.

Down to the plain, from their wooded fastness, came the Romans to meet the enemy and to begin the terrible fight. At first, victory seemed with the Sabines, for their general, Mettius Curtius, drove the Romans back the entire length of the Forum, even to the gate of their own city. But at that desperate moment, Romulus prayed to Jupiter for help, and immediately, so the story goes, their flight was stayed, and they turned with fresh courage to the battle.

But now the Romans seemed to have won the day, for, when the fight was fiercest, they pursued Mettius Curtius until he and his horse sank in the large pool in the hollow of the plain; whereupon, believing him to be lost, they turned another way. But Mettius, forced to desert his faithful beast, struggled bravely in the mire, and, encouraged by the affectionate words of his people, dragged himself from the marsh. Then, amid the shouts and the rejoicings of his fol-

lowers, he led them once more to the strife, and, in honour of his bravery, men called this place the Lacus Curtius, or the Lake of Curtius.

Yet to neither Roman nor Sabine was given the victory of that day, but rather to their women belongs the glory; for to the battle-field they came, full of horror at the dreadful slaughter, crying out, "Peace! Peace!" and filling the air with wails and lamentations. So great indeed was their distress, and so loud were their entreaties, that the terrible contest was stopped, and a council of peace was held between the two kings and the chief men of their peoples.

This council met on a quiet spot just beyond the market, and it was agreed that their tribes should be united as one people, and that Tatius should rule equally with Romulus. Tatius chose as his home the hill called the Capitoline, while Romulus remained on the Palatine, but they still came together in the valley between, on the place where the treaty had been made, to consult with their wisest men about the government of the people. And this place was thereafter known as the Comitium. Here Romulus sat in judgment upon the people, here were held the first meet-

ings of the Senate, and here were made the beginnings of the laws for which the Romans were so famous.

Just above the Comitium, Romulus raised an altar to Vulcan, the god of Fire, who, in his great forge, makes all the thunderbolts of Jupiter, and fashions the armour of the gods. The ground about this shrine was called the Vulcanal, and was one of the most ancient of the sacred places of the Forum, and upon it grew two great trees — a lotus and a cypress — which for eight hundred years, men say, gave shade to those who worshipped there. On this spot the two kings met secretly in time of trouble, and offered sacrifices for the welfare of the State, and there, also, as a thank-offering to Vulcan, Romulus placed a bronze chariot with four bronze horses, a treasure seized from his enemies, the people called the Camerini, over whom he was twice conqueror; and besides this, to remind all men of his power, he ordered his own statue to be made, and on its base he caused to be graven a list of all his glorious deeds.

Not very far from the Vulcanal, Romulus made another altar—one to Janus, the god of Entrances,

to whom the gates and doorways were sacred, and who, because of his double face, could see both backward and forward.

So, in the beginning of Rome's history, we find the Forum, telling us about three altars erected by the people to three gods, — to Saturn, to Vulcan, and to Janus, — to Saturn, because he gave the increase of the fields by which the men of their nation grew strong; to Vulcan, because he gave the fire by which the metal for their armour was melted and wrought; and to Janus, because he gave the protection by which their houses were made safe, and also because he was the god of all Beginnings — for were they not a young nation, standing in the very doorway of their history?

And under Romulus and Tatius the market was made better, for not only did the people from the neighbouring hill villages come there to trade, but the nation, grown larger by the conquest of other tribes, now had need of more things — of more food and clothing, and of more tools with which to build. And the woods were cut down, houses were built, and the marshy land was somewhat drained, while across it was made a way on

which the Romans and the Sabines passed and repassed on friendly business; and this road, which lay between people once such bitter enemies, became a path of peace, a sacred way, or the Via Sacra, as it was called years afterward when it was " Rome's proudest street," and the chief one of the Forum.

Still greater changes took place under Numa, the next ruler, who reigned alone, as did all the kings who followed him; and the buildings that he made on the Forum tell us that he taught the Romans many things.

Now Numa was a man so good and wise, that the Romans had sent messengers to his quiet country home to invite him to become their king; and when it was known that he was nearing the city, the people went out to meet him, and brought him into Rome with great rejoicings. Then they led him to the Forum, where all the citizens gathered together to prove that every man was content to have him king, and when this vote was taken the people agreed as with one voice, while their cheers rang far down the valley. Upon this, the chief men offered Numa the royal robes, but these he refused to

19

accept until he had first asked the favour of the gods, and to do this, he and the priests went up on the Capitoline Hill, while the crowd waited in great silence below. After he had prayed to Jupiter, some birds flew by on his right hand, in token, so said the wise men, that all was as the gods desired. Then Numa came down to the waiting people in the Forum, and, with shouts of joy, they hailed him as their king.

He ruled over the Romans many years, not only governing justly, but building wisely. First, he enclosed the public fire in a round temple to Vesta, the goddess of the Hearth, who had no statue, but was represented by the living flame that burned, not only on her altar, but in every household, and who was the special guardian of every home. And next to this he built a house, called the Atrium, for the young maidens, her priestesses; thus teaching this warlike nation the gentle duties of the home. Near the Temple of Vesta, he also built the king's house, called the Regia, where he lived as both priest and ruler; thus teaching the Romans that their king should direct the worship of the gods, as well as control the affairs of men. He also changed the altar of

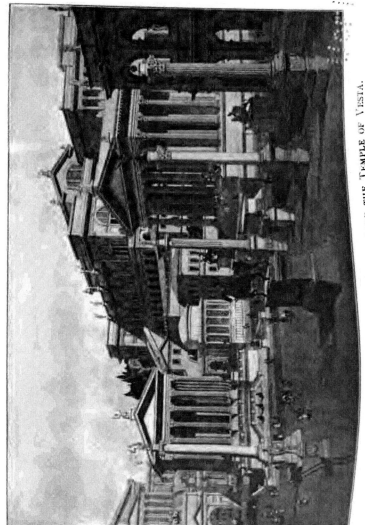

RESTORATION OF THE FORUM, LOOKING TOWARD THE TEMPLE OF VESTA.

Janus, the god of Entrances, into a temple having doors, which were to be opened in time of war, and closed in time of peace; thus teaching that the people set about with enemies must watch out from their entrances, but that those who are at peace need no sentinel, and may leave their gates unguarded. During all the days of Numa's reign, the doors of the Temple of Janus were shut, for he turned the fierce Romans from battle and conquest to the ways of peace, showing them how best to worship and to please the gods, and how to govern, and to make themselves good laws.

The makers of these wonderful laws were given a house by Tullus Hostilius, the next king, during whose reign no other building was added to the Forum. It was built on the Comitium, still the meeting-place of the ruler and his counsellors, and was called the Curia, or Senate-house, or, more often, the Curia Hostilia, after its royal founder. When Tullus first became king, the senators used to meet in a small hut of clay; for they no longer came together in the open air under the green trees, as in the days of Romulus. But this did not please the king, for not only was

it small, but its floor was often wet by the over-
flowing waters of the little brook Spinon; so he
caused it to be torn down, and he made there a
house of stone, entered by steps, and raised
from the ground so as to be safe from floods.
And there, in the Curia, on the Comitium, the
great Roman Senate met for many hundred
years.

After the building in which the laws were
made, came the building in which those who
disobeyed those laws were punished, and in the
side of the hill, just above and behind the
Comitium, Ancus Martius, the fourth king of
Rome, made a dreadful prison. Now Ancus was
the grandson of the good Numa, and, loving
peace and order, even as did that wise king, he
tried to make clear to all the people the meaning
of the laws. First, he had the rules, given by
Numa for the worship of the gods, written on
tablets of wood and hung in the Forum, that
every man might learn them; and then, because
there are bad men as well as good, he made the
prison, that the Romans should respect their
government and fear its power. But wrong-
doers were not many in the simple days of the

kings, and this prison was not at all like our
great prisons, with their barred windows and iron
doors; it was only a single cell, underneath the
ground, and hewn from the solid rock. After a
while, a second cell was made, over the first, but
still in the rock; and the prison became known
as the Tullianum, because of the little jet of
water, or "tullus," which sprang from the ground
of the lower cell. Small as was this prison, it
was held in dread by all men, for its two cells
told only tales of cruelty and horror. When the
prisoner had been tried on the Comitium, he was
brought up to the prison by a flight of steps,
leading from the Forum to the Tullianum, and
was fortunate indeed if kept in the upper cell, for
the lower dungeon was but a pit, cold and damp
from the waters of the spring, and almost without
air or light, its only opening being a round hole
in the floor of the cell above. Through this
hole the miserable victim was dropped into the
black depth beneath, and there was strangled,
put to death by torture, or cruelly left to starve.
No marvel then that the word "Tullianum"
filled the hearts of the people with fear! As
years went on, the Romans made other prisons,

23

but none were so dreaded, or so filled with terrible memories, as was this one of the Forum.

And now took place the greatest of all the changes made in the valley of the seven hills, for Tarquin, who reigned after Ancus Martius, drained the marshy land, and made it dry and firm, so that it was fit to bear large buildings, and the weight of many men. This king was called Tarquin the Elder because, later, another Tarquin ruled over Rome.

Great were the dreams of this first Tarquin for the glory of the Romans and for their city. He made great drains through the valley, built stone embankments along the sides of the river Tiber, that it should no more overflow the plain, and enclosed the little brook Spinon in a huge sewer called the Cloaca Maxima, or " the greatest of the sewers," which was made to pass under the Forum, at about its centre, and to empty into the Tiber.

These drains were not like our drains, which are large pipes made of clay or iron, but were formed of blocks of stone, so closely and so wonderfully fitted together that no cement was needed to hold them, or to prevent the water from leaking through. The work was done so

well that, although many hundred years have passed, these great sewers are still used by the city of Rome, and the vast Cloaca Maxima is pointed out to-day with the same pride that was felt by the ancient writer who boastingly said that it was so large that a Roman hay-cart could be driven through it, and so strong that a falling house could not shake it!

Then Tarquin went yet farther in his great work, for having prepared the ground, he planned to improve and adorn the Forum. Perhaps, as he looked upon the grassy plain at the upper end of the valley, he saw, not the market, nor the Senate-house, nor the rude temples, but beheld, instead, as in a vision, vast buildings and beautiful monuments, standing in the centre of a most splendid city — the Rome that was to be. So the King planned for the years to come, and ordered that the length of this large, open space be bordered by shops and houses, all having porticos facing the Forum, that the place should be regular both in look and form. And the King's will was done, for the men to whom he sold the plots of land about the Forum built as he had said.

The Forum, then, was laid out in a regular form by Tarquin the Elder, for which reason he is often spoken of as its founder; and its length and breadth were never changed from the days when, under his command, the people began to make their city great and strong.

Many other plans also had this mighty king, but his life was not long enough for the carrying out of them all, and his vast works were left to be finished by the last two kings of Rome. Little was done by Servius Tullius, the first of these, but Tarquin the Proud, a hard and unjust man, forced the Romans to give both their money and their strength to complete that which his grandfather had begun. In the Forum, he commanded the people to build a temple to Saturn on the place where the old altar stood, and he sent them under the ground to labour on the great drains, and made them toil, like slaves, without reward. At last, however, a day came when the oppressed people rose and said, "There shall be no more kings!" and Tarquin the Proud was driven from his throne, and the reign of the kings was ended.

The Forum, at this time, was the centre of a

nation growing strong and famous, and it told a
story of energy and progress — told by the great
drains, of the energy of a people who, from such
swampy ground, could make so firm a foundation
for their city; told by the temples, of their prog-
· ress in religion; by the market-place, of their
progress in trade; and by the Regia, the Curia,
and the Tullianum, of their progress in govern-
ment — and it stood forth as a sign to the peoples
of the earth that a great nation had been formed
among them.

In the time of the Republic, the first building
placed in the Forum told the tale of a great vic-
tory. This was a temple to Castor and Pollux,
the twin sons of the god Jupiter, and was made
in gratitude for their aid in an hour of sore dis-
tress. For Tarquin the Proud, striving to regain
his lost kingdom, had been joined by men from
other cities, and had come against the Romans at
Lake Regillus, not far from Rome, and during
this fierce battle Castor and Pollux, in glistening
armour, and on pure white steeds, had fought with
the Romans, and then, having won for them the
victory of the day, had brought to the Forum the
good news of their success. So the people hon-

oured the great Twin Brothers, the guardians of all brave warriors, and made a temple on the spot where they had stood.

However, all the battles of the Romans, in the time of the Republic, were not waged with enemies beyond their gates, nor yet with those of foreign lands, for many of them were fought among the people of Rome itself, and within the city's very walls. The chief field of battle was the Forum, and in it took place fight after fight in that bitterest of wars — the struggle between the rich and the poor.

Now the rich men of Rome were those of the old families, and were called Patricians because the *patres*, or fathers, had helped to govern the nation since the days when the chiefs had aided Romulus; while the poor men of Rome were those of the new families, and were called Plebeians because they were the "people," and had come in from conquered tribes or from other cities. So the Patricians were the governors, the law-makers, and the money-lenders; but the Plebeians were the workmen, the farmers, and the common soldiers.

In the long strife between these Patricians of

28

the Comitium, and these Plebeians of the open Forum, the rich fought for power, the poor struggled for justice. Often, after fighting for his country, the poor Plebeian came back only to find his lands seized and his home in ruins. This forced him to borrow from the rich Patrician, allowed by unjust laws to put him in prison when he could not pay, to sell his whole family as slaves, to torture, and even to kill him. These wrongs went on year after year until, moved by the sight of one man's cruel sufferings, the people rose against their hard oppressors.

For one day there came into the Forum an old and wretched man, on whose hands and feet were clanking chains, and round whose thin, starved body were only a few miserable rags. His long, white beard hung unkempt about his haggard face, and his eyes were full of suffering and despair. Changed and dreadful as were his looks, there were some in the crowd who thought they knew him, and who, turning to their neighbours, said : —

"Was not this man a brave soldier? Did he not serve Rome with honour? How has he come to such a pass?"

Whereupon the old man, standing before them in all his wretchedness, cried out that he was, in truth, the one of whom they spoke, and that he appealed to them as Romans for help in his sorry plight. He showed them on his breast the scars of nearly twoscore battles, and then, pointing to his back, on which were stripes fresh from cruel blows, he asked, "Are these the just reward for faithful services to Rome?" He told them, moreover, how when the wars were ended, he had found his house in ashes, his cattle stolen, and his lands unjustly taxed; and how he had been thus forced to borrow from a rich Patrician, by whom, when he could not pay, and was too ill to work, he had been thrown into the prison from which he had but just escaped.

This sad tale moved the people with great anger against the Patricians, and in the midst of the uproar that followed, horsemen, riding at full speed into the Forum, announced that the Volscians, enemies of Rome, were fast nearing the city's gates. At the call to arms, however, the Plebeians refused to fight, saying, with scorn, " Let the powerful Patricians save Rome!" Thus threatened from both without and within, the dis-

mayed Patricians knew not how to act. But, at last, one of the magistrates came forth from the Curia, and, at the wish of the senators therein assembled, spoke to the excited people, promising safety for the families and the lands of all soldiers defending Rome. Then the Plebeians — even the ill-treated debtors — enrolled their names, and in the battle that followed none were more brave than they.

However, the word of the magistrate was not always kept, nor was the soldier always sure of the safety of those he loved; for some years after this promise had been given a grievous wrong was done a fair maiden, named Virginia, while her father, Virginius, was away from home at the head of his troops. She was falsely claimed as a slave by Appius Claudius, a powerful, but base, magistrate, who was pleased with her great beauty and who caused her to be seized one morning as she entered the Forum on her way to school.

When, however, the people knew the wrong planned by the hated Appius, they made so loud an outcry that the maiden was allowed her freedom for one day more, in order that her father might appear to answer for her. And so, faithful

friends of Virginius rode at full speed to the place where the army was encamped, and told him of the danger threatening his fair daughter.

With anxious heart Virginius returned in haste to Rome, only to find Appius all-powerful, and the very laws changed to suit his wicked ends. Then, at the next daybreak, Virginius and his daughter, clad in the garments of mourning, were followed into the Forum by the young girl's nurse and Icilius, to whom she was betrothed, and a train of weeping friends; and there, before the assembled people, Virginius pleaded his cause at the judgment-seat of Appius. But when he found that cruel magistrate unmoved by pity and deaf to justice, he himself decided his child's fate. Leading her to one of the shops, he seized a knife from a butcher's stall, and, plunging it into her heart, cried out, " So only, dear child, can I keep thee free!" Then, holding the knife before him, he passed from the Forum, the throng making way for him in awful silence. And again there was an uprising of the men of Rome against their oppressors, and the people conquered, and gained some power in the making of the laws. From this time the Plebeians were less miser-

able, and as the years went on, some among them became honoured citizens, and even men of wealth.

Then the struggle between Patrician and Plebeian was for power in the government, and to reach his end, each used whatever means he could — means not always honest nor yet successful. Once more the Forum was the scene of contest, and this time victory was with the Patricians. It happened in a certain year when there was a great famine in the city, and much suffering among the poor. Spurius Mælius, a rich Plebeian anxious for public honours, seized this moment of need to win the favour of the people by selling them corn at a low price, or by giving it freely to those who could not pay. Through this use of his wealth, he not only hoped to become a magistrate of the Republic, but he also dreamed of greater glory — even the high honours of a king.

So, at least, the Patricians looked upon the matter, and, fearing for the welfare of the State, they appointed a dictator — a man whose office gave him an unquestioned right to command, but who only held his position during times of unusual danger to the nation. This honour was

now offered to Cincinnatus, a wise and coura-
geous man who had served Rome nobly, and
who, although over eighty years of age, was
trusted in this troublous hour beyond all other
men.

He ordered that the people assemble in the
Forum, and that Mælius appear before him for
trial. Then, having placed Patrician guards
throughout the place, he came with a strong
escort to his judgment-seat, and sent a young
officer, named Ahala, to seek out the ambitious
Plebeian. Mælius had come into the Forum
with many of his friends, but now, seeing the
fate that awaited him, he shrank back into the
throng, and refused to obey the command of
the Dictator. Whereupon Ahala, deeming him
a traitor to the Republic, rushed through the
crowd, and killed him on the spot. So, in this
struggle for power, a man's life counted as noth-
ing, and charity but as a covering for ambition.

Then came days when disaster overtook the
nation, and when Rome itself was laid in ashes.
The Romans had full warning of the coming
danger, but filled with the pride of conquest, and
sure of the strength of their city, they refused to

listen to the message of the gods, because it only came to them through a poor man of the people. As this honest Plebeian was walking in the Forum one night, and was passing through the street close to the Temple of Vesta, there happened a wonderful thing. The hour was still, and as he neared the sacred place, he heard a loud, clear voice, saying to him in tones more than human:—

"Marcus Cædicius! The Gauls are coming! Rome's walls must be strengthened!"

Now Cædicius was a good man, who honoured the gods and loved his country, and so, although the Gauls were a far-off people, not likely to venture against the power of Rome, he at once sought out the Plebeian leaders of the army, and repeated to them the unearthly command. But the proud officers turned him away with scornful laughter, and would not listen to what he said.

However, the time soon came when they bitterly repented their stubbornness and pride, for before long the fierce men of the North were within Rome's very gates. Then the proud Romans, who for three hundred and sixty years had been victorious over all their foes, were griev-

ously defeated, and forced to make terms with their savage enemy. The price of peace demanded by Brennus, the leader of the Gauls, was a thousand pounds' weight of rich gold. This the Romans brought into the Forum, that it might be weighed before their conquerors, but finding the Gauls using false weights, they angrily asked the reason of so great injustice. By way of answer, Brennus threw his heavy sword also into the scales, and said:—

"It meaneth woe to the vanquished!"

But the ancient writers tell us that this bargain was never carried out, for hardly had these insulting words been spoken, than Camillus, at the head of his army, arrived in the Forum. This great general was absent from Rome during the city's disaster, but now, in this hour of peril, he was sent for by the Senate, and was made dictator. At once rallying the Romans, and saying, "Rome pays in steel, not gold!" he threw the weights—even the scales—at the amazed barbarians, and drove them in confusion from the city.

So the nation was saved a great disgrace, but although the Romans kept their gold, they paid

dearly for this peace. For the Gauls had left Rome destroyed and desolate; they had torn down that which could not be burned, and had injured that which could not be torn down. Looking upon the woful wreck of their homes and of their city, the people cried out that they could not stay amid such ruin, but would begin their lives anew elsewhere. Then Camillus called them to the Forum, and, as the mourning multitude stood before him, there, among the ruins of what had once been the city's pride, he spoke to them of the noble deeds of their ancestors, and, pointing to the temples, asked, "Is this the time for you to leave the city of your fathers? Is this the hour for a Roman to desert his gods?" So he put new courage into the hearts of the people, and they set about the rebuilding of their Forum and of their city; and for his wisdom in this sad hour, Camillus is known as the second founder of Rome. Among their first works, the repentant Romans, in atonement for their neglect of the warning given them by the gods, made an altar, near the Temple of Vesta, to Aius Locutius, the Speaking Voice.

And now a disaster happened to the Forum

itself, for the ground fell in, forming a great abyss, in that part where, before the Tarquins drained the valley, was the pool called the Lacus Curtius. This deep hole the Romans laboured to refill with earth, but although each man did his utmost, their efforts were in vain. Then the priests consulted the will of the gods, but both they and the people failed to understand the message, which declared that the chasm could not close nor the State prosper, until a sacrifice had been made of that on which Rome's greatness was founded. Then, from among the young men, came forth one named Marcus Curtius, who asked : —

"Tell me, O men of Rome, has the nation aught of greater value than a brave man, armed in her defence ? "

No voice denying him, he stood for a while looking toward the shrines of the gods in the Forum, and toward the temple of great Jupiter on the Capitoline Hill; then, stretching out his hands toward heaven, he offered himself as the sacrifice. Then he clad himself in full armour, caused his horse in finest trappings to be brought, and, while the people stood around in silence,

gave a last look toward the heavens, and straight-
way leaped into the abyss. The men and women
threw in over him fruits of the earth and other
offerings, and immediately the ground closed
and became firm as before. And the place was
named, some say, for this brave youth, and not
for the Sabine general of the days of Romulus;
but of the truth concerning this who can tell?

Now, not long after, three monuments were
made in the Forum, the one closely following the
other. Two of these told of further progress in
Rome's own government, and one of them of
Rome's honoured place among the governments
of the world. For near the Comitium was a
covered porch, called the Senaculum, where the
senators might assemble before entering the
Curia, and where, also, they met to consult with
such magistrates of the people as were not allowed
within the Senate-house itself. Then, at the edge
of the Comitium, on the Forum side, there was
raised a platform, called the Rostra, from which
the laws and the actions of the Senate were
explained to the populace — the people now hav-
ing a voice in the government, and their good-
will meaning much to those in power. From

here, too, speeches were made by orators who sometimes arrived at the place before daybreak, that their words might be the first to influence the throng; for the quick-tempered Romans were easily moved, and, as the wind the reeds, so the orators swayed the multitudes, often exciting them to riots and even to bloodshed. The third of these monuments was on the Comitium itself, just in front of the Curia. It was an enclosed terrace, called the Græcostasis, and in it ambassadors from foreign countries listened to speeches from the Rostra, or awaited the pleasure of the Senate to receive them.

As this story of the Forum goes on, it tells, not only of Rome's growth and progress, but also of its joys and sorrows; for to the Forum, the place of the people, the Romans always came whenever the city was stirred by good or ill. At one time, the sad news was brought that the entire army had been taken by the Samnites, the nation's foes for many years, and that Rome had been forced into a disgraceful treaty. Upon learning this, the people, stripping off their ornaments, and putting on their plainest robes, came to the Forum, where, without any order from the

Senate, they closed the shops, and stopped all business, in token of their grief and shame. Then there followed a time of general mourning for the loss of Roman valour, and for the dishonour of the nation.

At another time, when the Romans had conquered these same Samnites, and had brought back much booty, among which were many splendid shields adorned with gold, the people were beside themselves with joy and pride. And they came in gayest dress to the Forum to celebrate the triumph by a feast. Over the shops of the silversmiths they hung the shields of the Samnites, thus adding to the decoration of the Forum, and showing that Rome's honour was avenged. So great, indeed, was the rejoicing over this victory, that these magnificent shields were set apart as sacred to the gods, and were always shown in the Forum whenever grand processions, or the great games took place.

At such times the Forum was, of course, thronged with crowds eager to see the splendour and the glitter of the celebrations; but even when there was no special excitement, the Forum was filled, all day and every day, with a busy

multitude of many kinds of people. For besides those who came on regular business, there were those who came to the Forum on all sorts of other matters — to seek advice from cheap lawyers, to buy slaves at public auction, to engage cooks, flute-players, and dancing-girls for some grand feast, or only to idle away the sunny hours in lazy gossip with a friend. In the middle of the Forum, around a gutter for the rain-water, were usually found miserable loafers and drunkards; so the men of honourable character chose rather to walk at the lower end of the Forum, although, in those days of the Republic, men of humble station might speak freely with the noblest of the throng. Children played about on the steps of some of the buildings; fine ladies came to the shops to buy perfumes, jewellery, and silken stuffs; and beggars and pickpockets moved in and out among the ever changing crowd.

Now this mass of people in the Forum greatly annoyed some of the haughty Patricians, who disliked to come too close to men of humble birth, whom they looked upon with much contempt; and among those who complained most loudly of the crowded Forum, was Claudia, a lady

of high rank, whose brother had once been consul. Under his unwise command, however, the Roman fleet had lost many hundred lives, and another such disaster would have greatly lessened the number of Rome's citizens. One day, as the proud Claudia was borne in her litter through the busy Forum, and her slaves were with difficulty making their way, she looked out, full of scorn, upon the press of people.

"I would my brother were alive, and that he were again admiral!" said she.

However, as the years went on, the number of citizens not only became greater, but so much space was taken up by statues and columns, placed there to men whom the city desired to honour, that the living crowd of to-day could hardly move in and out among the marble multitude of yesterday.

So Cato, one of the chief magistrates, wishing to please the Romans, and to make more room in the Forum, built a basilica, which he placed near the Curia, and called the Basilica Porcia, after his family name Porcius. Now this sort of a building was new in Rome, and greatly delighted the people; and its porticos, giving shelter from the

sun and from sudden showers, soon became the favourite place of meeting and amusement. After the success of the Porcia, several other basilicas were also built in the Forum. The first of these was the Basilica Fulvia, made near the silversmiths' shops, and close by the Temple of Janus; then followed the Basilica Sempronia, placed near those shops which were on the north side of the Forum; and, some time later, the Basilica Opimia was built, near the Temple of Concord. Each of these basilicas was erected by some one of the chief magistrates, and was called after the family of its builder. The name of the Fulvia, however, was twice changed, for members of two great families made it, in turn, larger and more beautiful, and it became known first as the Æmilia, and then as the Paulli.

In the court rooms of these basilicas was carried on much of the law business that before this had all been done out of doors at tribunals, or judgment-seats, placed in different parts of the Forum; but these tribunals were not all taken away at once, many years even passing before they entirely ceased to be used. Being of wood, they were often torn to pieces during riots, and used as a

means of attack and defence; they were also easily moved, when space was needed for a large assembly, for the shows of the gladiators, or for any great feast. And, in truth, much room was often necessary, for when the gladiators fought, so vast were the crowds that they even overflowed into the streets which overlooked the Forum; sometimes, too, hundreds of people sat down to tables spread there for the entire populace. Some of the most magnificent feasts of the Forum were given at the funerals of great men; but of them all, none were more splendid than was the one in honour of Publius Licinius Crassus, at one time Pontiff, or High Priest. His funeral ceremonies lasted three days, for one hundred and twenty-five pairs of gladiators fought around the funeral pyre, and not only was a gift of meat made to the people, but all Rome was bidden to the feast.

While the multitude were feasting, a great storm arose. The wind struck the Forum in such violent gusts that the tables were over-turned, and the rain fell in such torrents that the people were drenched, and forced to make themselves tents, of whatever they could find — cloths, cloaks, and coverings of any kind. And

so was fulfilled a saying of the soothsayers that, of a surety, a day would come when tents would be pitched in the Roman Forum.

Now as Cato pleased the Romans by the building of a basilica, so other men sought to win public favour in other ways. And a certain man, named Mancinus, greatly desiring to become consul, thought of a way in which to bring himself to the notice of the people, and, at the same time, to gain their good-will. He caused large paintings to be made of the siege and destruction of Carthage, the chief city of the Carthaginians, a distant nation long at war with Rome; and these pictures he hung over some of the shops in the Forum, and he himself showed them to the curious populace, — for it happened that he had been the first Roman to enter Carthage. So, using his fame to aid his ambition, he told the people of his own adventures, explained to them the position of the army, and answered, with untiring patience, the many questions asked by men of both high and low degree. Thus his good-nature won for him the liking of the people, who elected him consul, even as he had planned.

At the lower end of the Forum, near the

Regia and across the Sacra Via, was now made
an arch. It served as an entrance to that part of
the Forum, and was called the Arch of Fabius,
because it stood as a sign of triumph, marking
the victory of the consul Fabius over the Gauls,
and telling that Rome's ancient enemy was meet-
ing with Rome's revenge.

And at the upper end of the Forum, on the slope
of the Capitoline Hill, a large building was soon
afterward erected, called the Tabularium. It was
a place for the safe-keeping of the Records of the
State, and it held, engraved on tablets of bronze,
deeds of importance, treaties of peace, and decrees
of the Senate; and it told of the order and sys-
tem of the government and of the dignity and
power of Rome.

And now was added to the Forum a building
whose story was different from that of any other.
Until now, the buildings and monuments there
have told how the Romans reverenced their gods,
and how they won victories at home and abroad;
how they honoured their brave men, and how
they punished their evil-doers; how they improved
their Forum, and how as a people they gained in
power. But this building told of a great change

47

in the entire government of their nation, for it
formed a link between the two chief periods of
Rome's history. It was a basilica, placed between
the Temple of Castor and Pollux and the Temple
of Saturn, and it was begun in the last days of
the Republic, by Julius Cæsar, the greatest of the
Romans; but it was finished in the first days of
the Empire, by Augustus, the greatest of the
Emperors. It was known, however, as the Basil-
ica Julia, because of the wonderful man who
commenced it; for although Augustus was the
Emperor, Julius Cæsar was the greater of the
two. For it was Cæsar, conqueror and states-
man, who was so great in mind, and so strong of
will, that he won his way, step by step, to the
highest position that could be given by the
nation; and it was Augustus, Rebuilder and
Beautifier of Rome, who received, but only as a
legacy, the place and honour of supreme ruler.
During the last years of the Republic, the long
struggle between the Patricians and the Plebeians
became a contest for power among two or three
ambitious men. And Rome, weary of the rule of
tyrants — for such were the consuls at that time
— would have gladly placed the entire govern-

RESTORATION OF THE FORUM, LOOKING TOWARD THE BASILICA JULIA.

RUINS OF THE FORUM, EARLY PART OF NINETEENTH CENTURY.

ment in the hands of one just and strong man.
Julius Cæsar, already dictator for life, would have
been made king had not the jealousy of evil men
ended his life, for he died covered with wounds
given him by assassins and associates. And so this
vast basilica, the largest building in the Forum,
told a story in two parts—the first, about the end
of the Republic and the loss of Roman liberty;
the second, about the beginning of the Empire
and the increase of Roman splendour.

In the time of the Empire, the first monument
placed in the Forum was a type of all the mag-
nificence that was to follow; it was a column of
gilded bronze, set on a base of beautifully carved
marble, and was called the Milliarium Aureum,
or the Golden Milestone. It was put up near the
Temple of Saturn by the Emperor Augustus, and
on it by his order were marked the names and
the distances of the chief towns on the highroads
that led from the thirty-seven gates of Rome.
So this Golden Milestone told a long story about
the great changes that had been made by the
Romans, not only in the valley of the seven hills,
but throughout the whole land of Italy. For it
showed that in those places where, in the early

49

times, and in the times of the kings, small tribes had lived in simple huts, there were now thriving cities, full of busy people and of fine buildings. And it told also of the wisdom of the Romans — the most famous of all road-builders — who, by these wonderful highways, bound each town to Rome itself, and thus made the centre of the nation mighty, even as a great tree upholding many wide-spreading branches.

Over this realm Augustus reigned supreme; yet, in the midst of all his power, he did not forget the great man who had made the Empire possible, for among his first works, he built a temple in the Forum to the memory of Julius Cæsar. This temple stood near the Regia, on the spot where Cæsar's funeral pyre had been made, and it told of the affection of the Roman people, as well as of the gratitude of the Emperor, for, although erected and dedicated by Augustus, its building had been first planned by the magistrates of the Republic. In the same year in which the Emperor paid this homage to the memory of the great dictator, he himself received high honours from the Senate, who offered him a triumphal arch in the Forum.

This Arch of Augustus spanned the Sacra Via, near the Temple of Cæsar, and it reminded men of those great victories in Dalmatia, in Egypt, and at Actium that had made him master of the Roman nation.

However, Augustus was not only a brave warrior, he was also a great builder; and during his reign, still remembered as a "Golden Age," the Forum shared with the city in the many improvements and adornments that he made. Thus Romulus began Rome, Tarquin the Elder laid its foundations, Camillus raised it from its ashes, and Augustus beautified it. For from plain and simple brick structures, the buildings were now remade in marble, ornamented with all that art could bestow, and were wrought in all the beauty that man's mind could conceive. The Emperor also finished many of the works that Cæsar had begun; and because of the ever increasing number of the citizens, as well as to add to his own glory, he built a new forum, even as Cæsar had done before him. So the Forum of this story was no longer the only one in Rome; but it was always the one most dear to the people, it was always the centre of their life, and men spoke of

it as *the* Forum, even as they do to-day, for there is no place in all the world so full of the memories of great men and great deeds; of the echoes of great tragedies and great triumphs.

One day when the Emperor came into the Forum, at the time of an assembly of the people, he beheld many of the citizens of his fair white city clad in sombre cloaks of grey. " Are these," he cried in indignation, " the lords and conquerors of the world?" and he commanded that henceforth no Roman should appear in the Forum without his toga, a long and graceful robe of white. For the citizens of Rome were alone permitted to wear this garment, forfeited by banished Romans and forbidden to strangers. Augustus, therefore, by this command, sought to make his subjects ever mindful of their proud birthright as Romans, and to have each remember that the greatest of good fortunes was that of having been born and bred in that mightiest of cities — Rome. When a young man became of age, the boy's toga, which was bordered with a stripe of purple, was changed with much ceremony for the pure white robe of manhood; and, after he had sacrificed to the gods of his home,

the youth was taken by his father and his friends to the Forum, where he was enrolled as a citizen. And when a man died, the toga still covered his body, brought by grieving friends to the Forum, where his funeral oration was spoken. So all his life, from his boyhood to his death, the toga marked the true Roman from other men.

This Emperor gave much thought to the pleasure of his people, for he not only entertained them by feasts and games, but he showed them in the Forum all sorts of curious things from strange countries, and many works of art, such as paintings, bronzes, and marble statues. Great, too, was his care over them, for he sent extra guards to protect their homes from thieves while they themselves were at the games and festivals. He also caused a huge awning, such as had first been used by Julius Cæsar, to be spread over the entire Forum. This awning, which some say was of silk, was allowed to remain all summer, the season being very hot; and the sockets for the poles that supported it can be seen to-day in the pavement of the Forum. In return for all his kindness, Augustus gained the love of his people, who called him the " Father of his country."

Now the place in the Forum where the Lacus Curtius had been was held sacred, and was marked by an altar; close beside this was a well, and about it were growing a vine, an olive and a fig tree, giving welcome shade to the passer-by. The spot was believed to be a place of good fortune, and here, once a year, the people came, rich and poor, knights and labourers, to throw a piece of money into the well and to pray for the health of the Emperor. So all the Romans wished their ruler happiness, for he was a man with many friends, and among those whom he knew best were the three great poets, Virgil, Horace and Ovid, from whose beautiful verses so much has been learned about the Forum and the people of their day.

Sad and terrible was the story of the Forum during the reign of Tiberius, a cruel and wicked man, who was made Emperor after the death of Augustus. The story showed the beginning of the downfall of mighty Rome, and was told by two different structures. Of these, the first was another triumphal arch; this was called the Arch of Tiberius, and was raised over the Sacra Via, near the Temple of Saturn.

54

Tiberius received this honour because his kinsman, Germanicus, had been victorious over some of the Germans, and had regained the standards lost by Rome in a former dishonourable defeat. But, although called an arch of triumph, it was in reality an arch of disgrace, for it showed that Roman valour was now held so lightly that even the highest man of the nation was willing to profit by another's bravery, to conquer by another's hand, and to be praised for another's deeds. This Arch of Tiberius stood for selfishness and untruthfulness, and was, indeed, a sign of the times, for with the Empire's wealth and magnificence had come the loss of Roman nobleness and bravery. There were many nobles, but little true nobility; many bravely dressed, but few brave at heart. The people no longer assembled to make the laws, but came together, for the most part, only to feast and to be amused. Over them the Emperor ruled with a power that none dared gainsay, but that many ambitious men plotted to destroy, while others schemed, in turn, to ruin these. So Rome might well have been likened to a fine garden, full of rare growths and costly marbles, but whose paths so turned and

twisted that all who walked therein were lost in the mazes of a labyrinth, whence there was no escape.

Not far from the Arch of Tiberius was the structure that told the rest of this part of the Forum's story. It was the stairway that led from the Forum to the Tullianum, that dreadful prison begun by Ancus Martius, in the times of the Kings. These stairs were called the Scalæ Gemoniæ, or the " Stairs of Sighs," for they told of horrible cruelty and suffering, of gross abuse and injustice. The bodies of those who had been strangled or tortured in the dungeons of the prison, were thrown out on these steps, where they were sometimes left for days. At other times, the corpses were rolled down these awful stairs, and, after having been dragged by great hooks through the streets, were cast into the Tiber.

Now as envy and the love of power go hand in hand, the Emperor Tiberius feared and hated successful men, and he was jealous, above all others, of his popular nephew, Germanicus. He therefore sent Piso, one of his spies, to Syria, of which distant province Germanicus was then governor. Not

long afterward, news was received in Rome that the brave Germanicus was dead. Piso, accused of having given him poison, at a time when they were feasting together, was brought to trial before the Senate, and, although it could not be proved that he had done this dreadful thing, the people were furious against him. While he was being tried, the maddened mob dragged his statues from the Forum, and rolled them down the Scalæ Gemoniæ. To the crash of the marble they added loud shouts of anger, and demanded that Piso's own body be flung out before them; and in order that the enraged people might not tear him limb from limb, many guards were sent to protect him as he went back to his home. There, no help coming to him from the Emperor, whom he had faithfully served, Piso, giving up all hope, killed himself, and thus avoided a yet more horrible death.

No man was safe in those days of treason and conspiracy, and to be known as the friend of the Emperor was to be in constant danger of one's life. Even Tiberius's minister, Sejanus, fell at last under the Emperor's suspicions, and became a victim of the awful prison.

For three whole days the corpse of Sejanus lay on the Scalæ Gemoniæ, where it was insulted by the angry crowds, who vented on the body of this wicked favourite their hatred of his still more wicked master. But the Emperor did not stop here, and soon afterward the children of Sejanus were also put to death in the Tullianum. His youngest son and little daughter were taken by rough men to the prison; the boy was silent and seemed to know that he must die, but the tiny girl did not understand, and was frightened, like a child fearing to have done wrong and dreading punishment. As they dragged her along, she cried out pleadingly to the jailers, asking them what she had done amiss and whither she was being taken. Then telling them that they might use the rod and strike her if they wished, she promised, again and again, to be good, to be very good indeed. But her pitiful cry fell upon deaf ears, and even the tender bodies of these little children were thrown upon the Stairs of Sighs.

Among these terrible tales of the Scalæ Gemoniæ, there is one gentle story, a story of loving faithfulness, although shown only by a dog. It happened when the Emperor Tiberius con-

demned to death a man named Sabinus, whose
only crime was that he had been too good a
friend to the popular Germanicus. With Sabi-
nus were also killed his slaves, and to one of
these belonged a dog that followed its master to
the prison, before which it watched day and night,
in the vain hope that he would again come forth.
But when, at last, the doors were opened, the poor
dog was in great distress, for amongst others,
the body of its owner was thrown out upon the
stairs, and there lay in awful stillness. Then
the dog stole bread, and tried to feed its master,
staying faithfully beside him until men came and
dragged the bodies away to the Tiber. Yet even
there the loving animal did not desert its friend,
but following, as the waters closed over him, it
struggled with all its strength to keep its master
afloat and to bring him to land. Only a dog!
but showing more humanity than the men of
those cruel days.

Now a great disaster befell the Forum during
the reign of Nero, the last of the line of Julius
Cæsar and the most cruel man of those cruel
days. He caused Rome to be set on fire, in
order that narrow, winding streets and small,

ugly houses might be destroyed; for the city was to be made more beautiful and so his own fame rendered greater. Then, unmindful of the terror and the suffering of his people, this Emperor stood upon a tower, watching Rome in flames, and singing even as he watched. Many of the buildings and monuments of the Forum were sadly injured, for the fierce fire lasted for six days, sweeping away, not only the old and ugly parts of the city, but destroying also much that was new and beautiful. So Rome lay again in ashes. Nero and the emperors that followed rebuilt the Forum and the city, both of which, however, suffered again and again from fires in the years to come, and were as often restored.

Now at this time there were in Rome certain people who did not believe in the ancient gods, but who prayed to a God not made with hands, whose Son had been born in a manger at Bethlehem, and whose word of Truth had been brought by the Apostles Peter and Paul even to this great and wicked city. These people were called Christians and were much hated. So Nero, to screen his own evil deed, accused them of having set Rome on fire, and for this they were made to

suffer dreadful tortures, and many of them were most unjustly killed. Some old writers tell us that about this time St. Peter was imprisoned in the Tullianum, where, according to their story, there was no jet of water, but only a floor of solid stone. And they say that while in this dungeon, St. Peter turned the hearts of the jailer and his family to the love of Christ, and that at his earnest prayer, a spring gushed from the rock, with which heaven-given water the new believers were baptized. Some deny this story, some think it true, but however it may be, there were certainly many Christians in Rome during those terrible days of Nero; and notwithstanding ill-treatment and torture, they became ever greater, until the armies of the Roman Empire went forth to conquer under the sign of the Cross.

For many years the Romans still worshipped after the manner of their fathers, and it was not long before another temple was added to the Forum. The Emperor Titus began this building, placing it in front of the Tabularium, and erecting it in memory of his father, the Emperor Vespasian; but it was finished by his younger brother, the Emperor Domitian. Men usually

called it, however, the Temple of Vespasian, for, although it told of three rulers whose reigns brought happier and better days to Rome, Vespasian was the one best remembered. For he was the first to govern after the terrors of the year following Nero's death, when the Romans had three bad emperors; of these two were murdered and one died by his own hand.

From those days until their great Empire came to an end, the Romans were ruled and misruled by many different emperors. Rome's history was like a Wheel of Fortune that is running down, and the arrow of time pointed sometimes to trouble and sometimes to peace, then to power and then to weakness, often to ambition and often to cruelty, again to splendour and at last to ruin.

It was in one of these times of peace that another and last temple was made in the Forum. This was called the Temple of Antoninus and Faustina, and was built near the Regia by the Emperor Antoninus in memory of his wife. It told of the best ruler and of the best days that Rome ever had, for during the twenty-two years of Antoninus's reign, the vast Empire was at peace both at home and abroad.

Slowly and yet more slowly turned the Wheel of Fortune, and once, while the arrow was pointing to ambition and cruelty, another arch of triumph was raised in the Forum. It was called the Arch of Severus, and was built near the Comitium, and over the Sacra Via, and, while the Arch of Tiberius showed disgrace, this new arch showed crime. It told of triumph, because it was made in honour of victories in distant eastern countries; it told of crime, because it showed that a brother's ambition had been satisfied at the price of a brother's blood. At first, the arch was dedicated to the Emperor Severus, and to Caracalla and Geta, his sons; but Caracalla killed Geta in order that his own power might not be lessened, and then the name of Geta was cut from the arch. So by the word that was *not* there men read to-day of this terrible deed, and, in trying to make the world forget that he had a brother, Caracalla forced all men to remember his wicked ambition.

The story of the Forum is nearing its close. No one structure, however, continues it, but all the temples unite to show what happened next, and then all the buildings join together to tell its mournful end.

The temples tell that a time came when the ancient worship of the Romans was forbidden, when the gods were dishonoured, and when on their altars were seen the emblems of the New Faith. For one of the emperors, named Constantine, had openly become a Christian, and later, Theodosius, another Christian Emperor, commanded that none should bow the knee to any save to the One True God.

And now from every part of the Forum comes the dreary story of its ruin. So much of Roman strength had been needed to protect the far-off lands, conquered at great cost, that little energy or money was left with which to resist attacks from enemies at home. And the simple and powerful Nation of old was lost in the proud and vainglorious Empire. Thus Rome was conquered at last by the barbarians over whom she once so proudly held the mastery, and again and again they entered the city's gates and laid their destroying hands upon her vaunted glories.

In a half-hearted fashion the Romans restored some of the monuments and buildings of the Forum, and once the rough strangers themselves, feeling the power of the great memories that

filled the place, laboured to rebuild what they had torn down. But, for the most part, the beautiful structures were left in ruins, and their marbles were taken away for other buildings. The great Forum of Rome became a place of desolation, used by the people as a dumping-ground; and, as the years went on, its ruined temples, its triumphal arches, its great basilicas, and its other monuments were buried under the neglect of ages. Over the unsightly spot, kind Nature laid a covering of green, and the Italian people called the place the Campo Vaccino, or the field for cows. And there, in truth, where once Evander's herd had fed, the cattle were again pastured, and only a few columns marked the grave of Rome's past splendour.

Then came a time, not farther away from our own days than a hundred years, when men began to search for these great monuments, and to cast aside the earth and rubbish covering them. Many broken and scattered ruins have been discovered, but some of the things that the old writers have told us about have not yet been found. So carefully, however, have shattered columns been repaired and the stones of build-

ings replaced, that one can see to-day a part, at least, of what was there three centuries ago, and, with imagination's aid, can picture much of the Forum's bygone glories.

Nor is mankind yet satisfied, and so the search goes steadily on. The wonderful old monuments are being carefully uncovered, and discovery after discovery is being made of the marvels of the Past.

The story of the Forum itself is finished ; but so long as there shall rest one stone upon another, there shall not be silence within its boundaries. For, although its life is past, the Forum still speaks, and its tales, old, yet ever new, shall be told and retold in all the years to come.

II

THE story of the Temple of Saturn is a golden story, beginning in a Golden Age, and telling of a golden treasure. It begins in times so far away that man cannot discern things clearly, but, as through a soft summer haze, he may see somewhat of fertile lands, of great forests, of calm rivers; he may hear faint echoes of the lowing of cattle, of the call of the hunter, of the laughter of children; and thus he may know that the place on which he dreamily gazes is one of both peace and plenty.

That happy land was called Saturnia, because, so the old stories say, among its green hills and valleys a good king, named Saturn, ruled lovingly over his contented people. He taught them how to plant their fields, to build their homes, and to live aright: and in his days all men stood

67

equal and wanted nothing. The people were so joyous and the earth seemed so fair, that it was believed that the god Saturn himself had come to dwell therein; and those bright days of the years when the world was young are still spoken of as a Golden Age.

And so the legend grew, and it was said that Saturn's home was on the hill called by the Romans the Capitoline, and that at its foot an altar was raised to him, after he had disappeared from among mankind. This altar was placed there by Hercules, great Jupiter's mighty son, who taught those early people, not only to cease the sacrifice of human beings and to make less cruel offerings to the god, but to pray to him with their heads bare and free. For Hercules, like Saturn himself, had come from the far-off land of Greece, where the customs were unlike those of Italy; and thus he honoured the gods after the manner of his country. So it came to pass that in the Temple of Saturn, which in aftertimes stood in this altar's place, men worshipped with their heads unveiled, even as did the Greeks; the Roman custom, however, was to draw down the veil, that the sights of the

world might not turn the mind from the prayer muttered by the priest during the solemn stillness of the holy rites.

The Temple of Saturn, the oldest temple of the Forum, was begun in the days of Tarquin the Proud, and was built on a natural platform of earth on the side of the hill, and, when temples were made in the Forum to other gods, their foundations were made in imitation of this platform. Thus each of the temples was raised from the ground and was reached by a flight of steps. The number of steps in these flights was always unequal, so that, as an omen of good, the worshipper might put his right foot on the first and on the last step.

But before reaching the steps of the Temple of Saturn, the reverent Roman, coming to offer his sacrifice to the gracious god, first passed through an open space enclosed by a railing. This space was called the Area of Saturn, and, as he went along, the worshipper might stop to read some of the laws that were graven on the stelæ, or upright slabs of stone, that stood around the Area. Once, they say, a violent wind arose, and, when its fury was over, many of these

stelæ had fallen and were in fragments. Then the soothsayers cried out that the end of the Republic was at hand, and among those that heard them many lived to see these words come true.

But if it happened that the worshipper had not time to read the laws, he who truly honoured the gods would still linger a moment before the statue of Silvanus, which stood in the Area beneath the shade of a fig tree. For Silvanus was akin to Saturn, aiding him in his care over the fields and the forests, and having as his own special charge the boundaries of the farm, such as those of the pastures and of the corn-fields. The fig tree, near the statue of Silvanus, grew so large that its roots spread under the image, so that it was in danger of falling. To prevent this disaster, the tree was taken up, after prayers and sacrifices by the priestesses of Vesta, whose duty it was to attend all such solemn rites.

And now, at last, the worshipper, having paid his devotions before the altars that also stood in the Area, mounted the steps and entered the Temple of Saturn itself. Over its entrance were carved the figures of two Tritons, creatures half

men, half fish, holding aloft large shells, as if to
blow a warning note. Now the Tritons obeyed
the commands of Neptune, god of the boundless
sea, and, as over his blue domain they rode the
white sea-horses, they wound their big shell-
trumpets to still the rough, restless waves.
Across the waters from Greece they had safely
escorted Saturn, and their figures on his temple
seemed still to guard him, and as if ready to
quiet all disturbance that might come near the
sacred place.

Within the temple stood the statue of Saturn,
immortal protector of the earth's precious increase.
His image was made hollow, but was filled with
the oil from the olive, for did he not have the
green world under his care? and in his hand was
a sickle, for did he not reward work with rich
harvests? and about his feet were bound ribbons
of wool, for did he not also guard the animals of
the farm?

So it was Saturn that watched over the wealth
of the early Roman people, for in those days
their riches lay in their fields and in their flocks.
Then when the Romans had grown greater, and
their wealth was counted, not in golden stores of

grain, but in shining bars of gold itself, what more natural than that Saturn should still guard it, and that, even as other gods had in their care other treasures, he should have in his temple the public riches of the whole Roman nation?

Now in the first days of the Republic there was a consul named Valerius, who, because of the help he rendered the people, became known as " Poplicola," or the " People's Friend." He it was who ordered that the money belonging to the State should be placed for safe keeping in a strong-room made under the floor of the Temple of Saturn; for Rome was not only growing larger, but was constantly at war, and much money was needed both for the city and for the army. So each citizen gave to the nation according to his means, and for this reason Poplicola allowed the people themselves to elect as treasurers two young men called quæstors. These officers were under the direction of the Senate, and thus the Ærarium, or Treasury of Rome, was watched over by both the god and the government.

At first, the money placed in the Treasury was only bars of copper, on each of which was

stamped some figure, as of an ox, a sheep, or a fowl, for in the early times all debts had been paid and all exchanges had been made with such animals. Later, rough copper coins were made, and some of them bore on one side the head of Janus, on the other the ship that had brought Saturn to Italy. Still later silver and gold were used. For many years all payments were made by weight — as at the time when the Romans weighed out the ransom demanded by Brennus, the Gaul — and scales were kept in the temple for this purpose.

Besides the money, both in bars and in coin, the quæstors had charge also of certain records of importance to the nation. Under their care were the accounts of public expenses, reports from all generals and governors of provinces; also sentences of death, names of ambassadors from strange lands, and the general record of births and deaths. But the quæstors had in their care another charge, one more precious than gold, more important than records, for in the Ærarium of the Temple of Saturn were also kept the Roman standards — emblems of the nation's courage, honour, and power. The

73

earliest standard under which the Romans went forth to conquer was a simple bundle of hay, placed on the top of a long pole, for they were farmer-soldiers and fought for their lands as well as for the glory of their country. But when Rome's name was mightiest, a golden eagle, holding in its claws a thunderbolt, was carried aloft before her victorious hosts.

To follow the standards wherever the nation's glory or honour called was the chief duty of a Roman, and no pleasure, no trouble, was great enough to keep him from obeying. Once, when a deadly pestilence had stricken Rome for two long years, and the people were overcome with sickness and sadness, certain of their enemies dared to carry their attacks close to the distressed city. Angered at this advantage taken of their weakness, yet alarmed at their peril, the Romans appointed a dictator. By his orders the Roman standards were brought from the Temple of Saturn, and, in the grey of the morning, were borne beyond the gates. And there every Roman who had strength enough left to carry arms rallied in answer to his country's need, and offered his life to save the city and to protect the help-

less sick and dying. Such men can never be conquered, and the standards were soon brought back to Rome in triumph.

After a time, the quæstors had yet one more charge given to them, for they were made also the guardians of the "sacred gold" of Rome. When the victorious Gauls had humbled Roman pride, the wisest among the magistrates took counsel together and decided that a fund should be put aside against times of extreme need, such as another war with those dreaded enemies from the north, or in case of any other pressing necessity of the State. This fund was called the Ærarium Sanctius, or the Sacred Treasury, and was also in the Temple of Saturn, where it was most jealously guarded. It was, however, entirely separate from the general treasure, and the money, which was in bars of gold, amounted to enormous sums as the years went on.

As their wealth grew greater, the Romans did not forget to honour the god in whose temple their treasure was so safely kept, but worshipped Saturn faithfully and once a year celebrated a great feast in his name. This was the Saturnalia, which took place in December, after the grain

was garnered and when man was ready for rest and for enjoyment; and the people were commanded by the Senate to observe this festival forever. It began with a sacrifice to Saturn in his temple, and was followed by a public feast, at the end of which the people gave themselves over to every kind of pleasure. It was as though men strove to recall once more the Golden Age, for during the Saturnalia they all stood equal and joyous freedom ruled the hour. Slaves were waited upon by their masters, prisoners were set at liberty, even criminals were pardoned, and no battles were fought during that happy time, which lasted for seven days.

Next to their faith in the power of the god to guard the nation's riches, was the confidence of the Roman people in the surety of the government to pay all the nation's debts; and such was their pride that, even to themselves, they would not acknowledge that the Treasury of Rome could fail. When the magistrates proclaimed that, on account of the expenses of the army during the war with the Carthaginians, there was no money left with which to make needed repairs in the city, the citizens, and especially the Ple-

beians, would not have the work stopped. The workmen themselves were the first to come forward to say that they would not ask for pay until the war was over, and soon after the money of widows, and of those that were under age, was placed in trust in the Treasury, to show the confidence of even the most unprotected. So great was the enthusiasm that the soldiers also refused their pay, and every Roman of every class vied with his neighbour to prove his pride and his trust in the Treasury of the Republic.

This, indeed, was not the only time that the Treasury was refilled by the united action of the people, for, during the war with Philip of Macedon, again the Romans supplied the wants of the State. The army had been made ready, but men were needed to row the fleet; for the Roman ships were not like our ships, which are driven by powerful machinery, but were moved by huge sails, aided by strong men at long oars. Now there was no money in the Treasury with which to hire these rowers, and without the fleet, how could the coast be protected? The Senate proclaimed that a tax be placed upon private citizens, and that each man, according to his wealth, bring

money to the Treasury. But the people were weary of paying for an army whose victories, although bringing glory to Rome, ended by leaving themselves poorer; so they came into the Forum in immense multitudes, and complained bitterly of the injustice of the tax. Upon this, another meeting of the Senate was held. The magistrates looked helplessly at one another. No money in the Treasury, no money from the people. What then was to be done? As they were still considering this matter, there rose from among them the wise Consul Lævinus, who thus addressed the assembly: —

"Those of high station and of noble name should set a right example to those of low condition and of humble birth. We should first do willingly ourselves what we would ask others to perform. So let us, senators and nobles of Rome, put into the public Treasury all of our gold, silver, and coined brass, only reserving those things which, being signs of our station, are due to our families. And let us do this before passing a decree upon the people, so that our zeal for the welfare of the Republic may inspire them by its pure ardour."

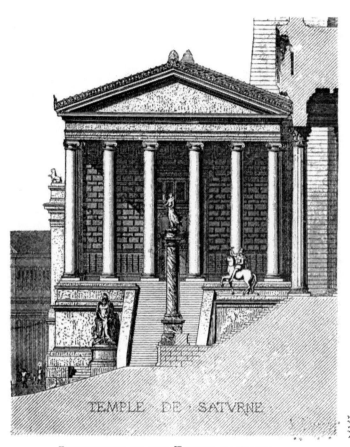

TEMPLE · DE · SATVRNE

RESTORATION OF THE TEMPLE OF SATURN.

In reply to these noble words, the Senate moved a warm vote of thanks to Lævinus, and then each member hastened to carry his gold, silver, and brass to the Temple of Saturn. With so much good-will did every man bring his portion, and with so much eagerness did he endeavour to have his name first upon the public register, that the clerks were hard pressed to enter all the contributions. Then, seeing the generosity of the nobles, the people were ashamed and quickly brought to the Treasury all that they were able to give. Thus, without any decree, or any use of force by the Senate, the fleet was provided with rowers, and more than this, a fund was added for their future support.

There was only one man that had no respect for either the god or the government protecting the Treasury of Rome, and yet he was the greatest Roman of them all. Forcing all things and all men to aid him in carrying out his mighty plans, Julius Cæsar, needing large sums of money for his army, seized upon this gold of the Ærarium Sanctius itself. This was not done, however, without much opposition from both the Quæstors and the Tribunes, the magistrates of the Plebeians.

But turning them all aside, Cæsar went into the Temple of Saturn and approached the Ærarium. Then one of the tribunes, named Metellus, placed himself against the locked doors, and cried out that Cæsar was breaking the laws of Rome, and that only through his own dead body should the sacred gold of the people be reached. At this, the great Conqueror grew angry and scornfully replied : —

"There is, O Metellus, a time for law, and there is also a time for war. When the last is over, I will speak with thee about the first. Rome and her people are now mine, and I shall do with all even as I will."

Having said this, Cæsar asked for the keys, but these no man was able to find; so he sent for smiths, who forced open the strong doors. Before he passed the threshold, however, Metellus spoke once more in warning and in entreaty, and some in the crowd around encouraged him. But Cæsar, raising his voice so that all should hear, made only a short reply.

"If thou disturb me further, I will kill thee," he said calmly; "and this, O rash man, is harder for me to say than to do!"

Whereupon Metellus shrank back in fear, and Cæsar possessed himself of the most precious riches of the Roman people. And men said that, for the first time, Rome was poorer than Cæsar — for he had many debts. Yet in making the city poorer for the moment, Cæsar enriched the nation for all time; for with his army he went forth conquering and to conquer, and the boundaries of Rome were widened until they reached from sea to sea.

Augustus, the next great Master of Rome, had the Temple of Saturn enlarged and beautified; but after his day there came a long pause in its story. The emperors had their own treasury, and, as their power grew, that of the State faded. The time of the people had gone by. In the reign of Carinus, a most wicked emperor, a great fire injured Saturn's temple, and after this it was restored, but hastily, and without care. Over the entrance were placed the letters S. P. Q. R., to show that the work had been done under the direction of the Senate and the People of Rome; for the next emperor, Diocletian, being a Christian, would not put his name on the temple of a god whom he denied. Soon the worship of all

the gods was forbidden, and the temple was no longer used even as a Treasury; and little by little it fell into ruins.

Eight columns of the portico now stand upon a part of the foundation, and these, with some steps that perhaps led to the Ærarium, are all that can be seen to-day of Saturn's ancient shrine.

The god of the Golden Age has deserted his temple, the Golden Treasure has been taken away, and the Golden story is ended.

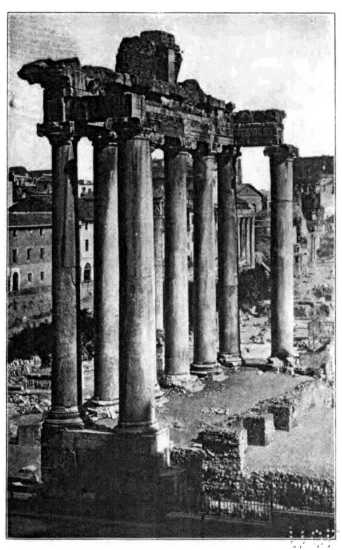

RUIN OF THE TEMPLE OF SATURN.

III

MANY, many years ago there was a terrible battle. In a marshy valley among some wooded hills, fierce men fought with one another, slaying without mercy. But there was no boom of cannon, no cloud of smoke, no roll of drum, no gleam of armour; for these warriors, clad only in the skins of animals, protected themselves behind rough shields, while they sought to kill with rude spears, and bows, and arrows. And yet the battle was long and deadly, and when the sinking sun told that the dreadful day was over, its last rays shone upon men in bitter strife. Then the chiefs of the armies caused the bloody work to cease, and met in council, that, if it were possible, a treaty might be made between them. As they passed along the battle-field, where lay dead so many of the strong men of their tribes, their hearts were heavy,

and in silence they reached a quiet spot at the upper end of the valley, and there they paused.

This place was at the foot of one of the hills, and was fresh and green from the waters of a spring, and on one side was a cave overgrown with ivy. There, under the great trees, the chiefs held parley, and before long word was sent to their wearied armies that the warfare was ended and that peace was declared. This council, between Romulus of the Romans and Tatius of the Sabines, was the first held on the Comitium, where for centuries those that guided Rome's affairs met to plan and discuss the ways and means of government.

And when Romulus and Tatius ruled together over the new nation, they met in this peaceful spot, just beyond the busy market-place, to make the first laws for their people; and here they also sat in judgment. Perhaps, however, as the number of the people increased, the noise of fetching and carrying, of calling and bargaining from the market, became too loud, and disturbed the law-makers in their serious consultations, for it was not long before a hut of clay was built for the kings and their councils, on that part of the Comitium where the

spring had been. Some years later, King Tullus Hostilius, thinking this hut unworthy such conquerors as the Romans, built in its place a house of stone, which faced the centre of the Forum and was entered by a flight of steps; and this Curia, or Senate-house, was called the Curia Hostilia, after the king.

As the chief meeting-place of those in whose hands was the government, the Curia became the most important building of the Roman world; and, even as the early laws were direct and clear, so this house was plain and simple; without, its walls were neither carved nor ornamented; and within, some wooden benches, and a chair and desk for the Speaker, were the only furniture of its long assembly-room.

It was during the reign of this warlike Tullus that a strange battle was fought between the Romans and the Albans, a tribe living among some hills not far from Rome. Each of these nations sought to prove itself the stronger, each was ever ready to seize upon the slightest cause for war. Now among the Albans were three brothers, stalwart, brave, and of the same age. Among the Romans were also three brothers,

strong, courageous, and equal in years. And therefore it was proposed that the three Albans, who were named the Curiatii, should fight the three Romans, who were called the Horatii. The result of this contest was to be taken as a proof that one nation was greater than the other, and the people of the conquered were to be ruled by the king of the victors.

So the Romans gathered vervain, the sacred herb from the Capitoline Hill, and carefully pulling it up by its roots, that none of its virtue be lost, they made of it sweet-smelling wreaths, which they gave to the heralds as a token of their grave office. Solemn rites were also held among the Albans; and between the two tribes passed heralds with royal orders and messages until terms had been arranged and accepted by both sides.

Then the Roman and the Alban army pitched their camps in a plain just beyond Rome, and the youths on whom so much depended met in the centre of the field. Each man was eager, each seemed to feel in himself alone the spirit of a whole army defending a country's honour. A breathless silence, then a clash of arms, a glitter of swords, and the deadly contest began.

Hard and fast, blow followed blow, until two of the Horatii fell lifeless to the ground. Then the Romans were dismayed, for the honour of their nation lay in the strength of one of her sons alone, and before him, although sorely wounded, stood his three enemies, still fierce, still fighting, and cheered on by glad shouts from the Alban ranks. Horatius was as yet unhurt, but he could not hope to win in such an uneven fight; so to his strength he added cunning.

Feigning flight, he ran from his foes, judging that their wounds would force them to follow at unequal distances, and planning to attack them one by one. And so it happened, for it was not long before one of the Curiatii ran beyond his weaker brothers, and Horatius, seeing this, turned suddenly upon him and felled him to the ground. Then, grasping still more firmly his victorious sword, he met the attacks of his second foe, and killed him even as he had done the first. Loud shouts of victory from the Roman army now filled the air, for they saw that the end of the contest was near. Weak from his wounds, worn out with running, and heart-sick over his brothers' fate, the last of the

Curiatii made no struggle, but fell before the exulting Horatius, who plunged his sword into his enemy's throat, crying triumphantly: —

" Two of you have died that my brothers might be avenged — the third shall lose his life that Rome may rule Alba! "

Then, led by Horatius, bearing the spoils of the vanquished Curiatii, the Romans returned rejoicing to their city. Near one of the gates, there stood among the awaiting crowd the sister of the Horatii. She watched the procession draw near, with anxious eye and beating heart, dreading, yet longing to know who were the victors, for although truly loving her brothers, she was betrothed to one of the Curiatii. And when she saw upon the victor's shoulder the military robe that with her own hands she had made her lover, she rent her hair and mourned aloud. Hearing her grievous cries, Horatius stopped, and, full of rage at this sorrow over the foe he had so hardly conquered, his anger blinded his affection, and, drawing his sword, he killed his sister where she stood, at the same time exclaiming: —

" So shall perish every daughter of Rome that dares mourn an enemy! "

The Senate and the people were full of horror
at this deed, and, in spite of the services just
rendered his country, Horatius was brought to
the Comitium for trial as a murderer. Justice
was about to be dealt him, when his aged father
came before the people to pray for his son's life.
He pointed to the spoils of the Curiatii, and
entreated that so brave a life as that of their
conqueror might not be so early ended; and at
length the youth was pardoned for the sake of
his great courage. However, sacrifices were
offered to the gods by his family, and he himself
was made to pass under a yoke, or beam, placed
across the street, as a sign that, although a victor,
he was also vanquished. This beam was called
the "Sister's beam," and was long kept in repair
by the Horatii family.

And on the Comitium there was raised a col-
umn whereon for many years were hung the
spoils of the Curiatii; and this column was called
the Pila Horatia, in honour of the man who had
won Alba for Rome.

From the beginning the Comitium was the
place of government, and its story is one of Law
and Justice. Here, the rights of both the nation

and the people were protected; here, both public and private wrongs were brought for judgment. And here, once a year, a sacred rite was performed for the cleansing of the guilt of the whole city. This was called the Regifugium, or the Flight of the King, although to-day no man knows why, for this ceremony first took place in ancient days when Legend led History through winding ways, now so overgrown that hardly a single path can be clearly seen. But true it is that here, on the Comitium, before the assembled people, the priest killed an animal — the symbol of all their sin — and then fled from it as from a thing of horror, lest some drop of unclean blood should fall upon him; and by this sacrifice it was believed that Rome was purified.

Now the priests were very mighty in those days, and often gave counsel in the affairs of government, as well as in those of religion, explaining the meaning of the signs and wonders by which the gods made known their will. So Numa had sought a sign from heaven before becoming king, and Jupiter, to show that Numa was acceptable to the gods as well as to men, had sent birds to fly by on the right hand of the

augur, the wise priest that could read such divine tokens. But the greatest of Rome's kings, Tarquin the Elder, doubted in his heart the power of the augurs, and, being angry because forbidden by them to carry out his will in a certain matter of government, he determined to prove them false before all the people.

Therefore, King Tarquin went down to the Comitium, at a time when many were in the market-place, and caused Attus Navius, the most famous augur of that day, to be called before him. Then, in courteous tones, which, however, hardly concealed a great scorn, the king thus spoke: —

"O diviner of the will of the gods, I have called thee to advise me in a grave matter. Canst thou, by thy vision of things unseen by ordinary men, tell me if the plan that is in my mind can be fulfilled?"

Bowing low before the king, Attus Navius went to a quiet place apart to consult the heavenly signs, but soon returned saying: —

"What Tarquin wills can of a surety be done."

Then the king laughed aloud, and showing the augur a razor and a whetstone, he bade him cut the one in two with the other. Whereupon,

Navius, with no sign of hesitation, took the razor in his hand and with one stroke laid the hard stone open. Then the king believed.

And from that day great respect was shown the augurs, no matter of either peace or war being undertaken by the Romans without consulting these wise men. A brazen statue of Attus Navius was placed upon the steps of the Curia, and the whetstone and razor were buried on that part of the Comitium where the miracle had been wrought. This spot was held sacred, and a sort of low stone fence was made around it, that no unholy foot should trespass upon it.

But this was not the end of the wonders done by Attus Navius; once more he proved his power to the king and to all the people. By the river Tiber there grew a fig tree, which, untouched by man, the augur caused to move to the centre of the Comitium, where it again took root. Beneath it was placed a group of a wolf and two baby boys; and the augur consecrated this spot also, for this tree had seen the very beginning of Rome's beginnings, and as it flourished, so, men believed, the nation itself prospered.

Long before the city of Rome itself was

founded, there had been a flood, and down the swollen waters of the Tiber had floated a basket in which were two young children. These little twin brothers had been set adrift by the wicked King Amulius, who had thus sought to end their lives because he feared that they, being also of royal blood, might in time take his kingdom from him. But the gods had willed otherwise, and the frail basket had been caught in the low branches of a fig tree, and soon the falling waters had left the babies safe upon dry ground. Then a mother-wolf had come and cared for them, even as for her own wild little cubs, giving them her milk and licking them with her tongue. And so Faustulus, a kind shepherd, had found them; whereupon he had taken them from their strange nurse and had brought them home to his wife, who had given them a place among the sons and daughters of her simple household.

These boys were called Romulus and Remus, and, when they had become strong and valiant youths, they slew the wicked Amulius. Then they purposed making a city of their own, by the river that had dealt so gently with them; but when the limits of their town had been laid out,

the brothers quarrelled, sad to say, and Romulus killed Remus. So Romulus alone founded Rome, the great city that still bears his name.

And this is why the Romans cherished the ancient fig tree on the Comitium, and why the bronze group of the wolf and the little children was placed beneath it. The kind shepherd, Faustulus, was buried on the Comitium, a stone lion marking his burial-place; and here, men say, Romulus himself was also laid. Some think that a flat black stone was over his grave, and others that two stone lions showed where he lay; but all that we surely know is that on the Comitium were placed several monuments, erected in memory of early Rome and of her founder.

Now Servius Tullius, who ruled after Tarquin the Elder, was a peaceful man that governed Rome well; and under his direction many wise laws were passed by the Senate in the Curia. And yet the end of this law-maker was lawless. But the story of the Comitium — always one of Justice as well as of Law — shows that the wrong was punished.

Although the son of a slave, Servius Tullius, because of the power of his mind and the gentle-

ness of his ways, had found much favour with Tarquin the Elder, who, as his years increased, left the government in his hands. Hence, after the death of Tarquin, Servius was naturally chosen by the senators as the next ruler, for the Roman kings were elected by a vote of the people confirmed by the Senate; a son did not succeed his father to the throne, as is now the custom. On account then of Servius's greater worth, Tarquin's sons were passed by; but being young and free, they were glad to leave serious matters to other men. However, it happened that one of them, also named Tarquin, married an evil woman, and from that time a great discontent seized upon him. Tullia, for so his wife was called, was the daughter of Servius, but she was as wicked as he was good, and she so excited the ambitious desires of Tarquin that he plotted to take the throne from Servius, now grown old.

Accordingly one day, Tarquin, attired in royal robes, and escorted by armed men, rushed into the Forum, and entered the Curia, where he took the king's seat, and commanded that a herald summon the senators to attend him, Tarquin, their king. Full of fear and amazement, the

95

senators obeyed, and Tarquin was in the midst of a long speech, when Servius came into the Senate-house.

"How now, Tarquin!" indignantly asked the king, "by what insolent daring dost thou assume my place?"

"By my right as my father's son, thou slave!" scornfully replied Tarquin. Then, as the people were crowding into the Curia, he felt that the moment had come in which to prove his might, and so, seizing the old king and carrying him to the porch, he threw him down the steps of the Senate-house.

Servius lay stunned for a moment, then, dazed and bruised, he staggered to his feet and looked appealingly about him, bewailing his misfortune. But from among the crowd no man came forward to help the fallen king, no glance of pity met his eye; all were on the side of the strong man who, casting aside the laws both of God and man, and standing commandingly before them, proclaimed himself master of Rome. Then the poor old monarch, hurt and bleeding, called his servants to him, and such as dared followed him as he started toward his home. This, however, he

never reached, for assassins sent by Tarquin killed him in one of the streets.

And as Tarquin was still standing in the porch of the Curia, Tullia, his wife, drove into the Forum in her chariot, and drew up on the Comitium before him. " Hail, Tarquin, king of the Romans!" she cried in a loud, exultant voice, thus being the first to salute him as king.

In this manner Tarquin gained his kingdom, but he held it by force, for he had neither the consent of the Senate nor of the people. His rule was cruel, and, because of the haughtiness of his ways, he was called Tarquin the Proud. And once, at least, his pride cost the nation dear. For one day a wise woman, called a sibyl, came to the king and showed him nine sealed books, which she offered for sale at a very large sum. But the king haughtily turned away, although she assured him that the books held words of deepest wisdom concerning the destiny of Rome. Then the sibyl burned three of the books before his eyes, and offered him the other six at the first price. But Tarquin only smiled in scorn ; whereupon she burned three more, and offered him the last three for the same sum as for the whole nine.

Then, at last, the proud king listened, and paid the amount desired, although his obstinacy had lost Rome that which could never be replaced; for in these volumes, called the Sibylline Books, were found wonderful things concerning the will of the gods, and directions whereby their wrath might be turned from the Roman people. A statue of this sibyl was then placed on the Comitium, in honour of her visit, and in order that all should know that Rome was guided by the direct decrees of the gods.

As year by year Tarquin oppressed the people more and more, their dislike for him ripened into hate; and Justice, working slowly but surely, at last overcame him. For the day came when, in that same Curia on whose steps Tarquin the Proud had denied all Law and had made himself king, the Senate assembled and passed a decree enforcing the laws of Rome, declaring her people free and exiling the tyrant and all of his house forever. So Tarquin the Proud ended his days in misery, but the memory of Servius is honoured even to this generation.

Within the Curia, laws were now made for the people by the people; for instead of a king, magis-

trates elected from among the citizens ruled the
nation, which became known as the Republic of
Rome. Under this new order arose the Patri-
cian and Plebeian classes, and in the Forum each
of these parties had its special place of meeting.
On the Comitium came together the Patricians,
for their ancestors had always aided in the gov-
ernment; in the market-place and the middle of
the Forum gathered the Plebeians, for they were
ever the business men and the labourers. But at
times the Plebeians would come in crowds to
the Comitium to insist upon their rights, and
on other occasions the Patricians would enter
the market-place in large numbers to beseech the
patience of the people. And so their struggle
for power went on.

At the beginning of the Republic, the large
open space of the Comitium was separated
from the rest of the Forum by a fence; and
within this enclosure stood the Pila Horatia;
the ancient fig tree, beneath whose shade was the
bronze group; the monuments marking the grave
of Romulus, and that of Faustulus, the shep-
herd; and the new statue just put up in
honour of the sibyl; while at the rear was the

plain stone Curia Hostilia, upon whose steps
stood the statue of the wonder-working Attus
Navius. Here, also, must have been some kind
of a tribunal, or judgment-seat; for in this place
the offenders against the laws were tried and
sentenced, and here, too, criminals were exe-
cuted.

One of the first two consuls of the Republic was
named Brutus, a stern and just man. Soon after
he had entered upon his office, some of the young
nobles of Rome were discovered in a plot to help
the exiled Tarquin. Betrayed by a slave, these
youths were brought to the Comitium for judg-
ment before the tribunal of Brutus, and among
the traitors the eyes of the unhappy father fell
upon two of his own sons. Not for a moment
did he waver, not for a single instant did he lose
sight of his duty as a judge, nor of his honour
as a Roman. With the other offenders, his sons
were condemned to death, and, in spite of their
entreaties, to which the assembled people added
theirs, the young men were led away by the lic-
tors. Now these lictors were the special servants
of certain magistrates, and bore as their sign of
office a bundle of rods bound around an axe.

With the rods they scourged, and with the axe they beheaded, and upon this occasion they were not permitted to omit any part of their dread duty.

On the Comitium, before all the people, the sons of Brutus met their just punishment as traitors to their country, while their father watched their execution, not as a man whose heart was broken with grief and shame, but as a stern judge whose faithfulness to Rome was above all else. And the people marvelled, yet rejoiced that the young Republic had so true and strong a man to guide her in those first troublous days.

And, in truth, those were times when Rome never lacked a brave man in an hour of danger, for with each peril there came a hero also. One of the Romans, whose courage gained for him great fame and honour, was Horatius Cocles, or the One-eyed, a member of the family that had already given three champions to the nation. Now, while this Horatius was yet a young man, Rome was besieged by Porsenna, king of the Etruscans, a neighbouring people, whose army had gained possession of the fortress on the Ja-

niculum Hill, opposite the city, and on the other side of the Tiber. Great alarm reigned among the Romans; the city's walls were strengthened in every part, and the gates were protected by many armed men. But there was one weak point in the defence, and there the enemy planned to make their attack. To connect the city with the fortress, a bridge had been built across the Tiber. It was called the Pons Sublicius, or the Bridge of Wooden Beams, for in its making no iron had been used; and by it Porsenna purposed to cross the river and to enter Rome. However, it happened that on the day of the taking of the Janic-ulum, Horatius Cocles was on guard at the bridge, and when he saw the enemy rapidly approaching, he called to his fellow-soldiers for assistance. But many of them were fleeing in terror within the walls, and only by brave words and still braver actions did Cocles prevail upon them to stand like Romans and to face the com-ing danger.

"Shall a foe enter Rome while a single man yet lives to defend her?" he nobly cried. "To the bridge! Cut down the bridge! The enemy must never cross!"

Then, choosing for himself the post of greatest peril, he waited at the farther entrance of the bridge for the arrival of Porsenna. With him went two other courageous men, and behind these the rest of the band laboured in all haste to tear the strong timbers apart.

Alone, those three brave Romans met the attack of the Etruscans; then, as the bridge was almost ready to fall, Cocles sent back the others, and, single-handed, faced the enemy. As the leaders hesitated to continue their attack on one man only, Cocles, with a free man's pride, called them, in scorn, " Naught but the slaves of kings!"

At this a storm of javelins fell upon him, but he caught them on his shield and remained unhurt. Just then a shout of joy from the Romans told him that their work had been successful and that the bridge was about to give way. For one instant only did brave Cocles pause.

"O Father Tiber!" he prayed to the god of Rome's great river, "take thy soldier into thy kind care!"

Whereupon he leaped, all armed as he was, into the stream, and, amidst another rain of javelins, swam safely to the shore.

Thus Rome was again saved from her enemies; and in gratitude the Senate erected a statue of Horatius Cocles on the Comitium, and granted him as much land as he could plough around in a single day.

And, strange to say, a few years later, a statue of Porsenna, the enemy so nobly withstood, was also placed on the Comitium. For, so some of the old writers tell us, the Romans made peace with the Etruscans, and in their ancient foe found a firm friend and faithful ally.

This statue of Porsenna was the first to be placed in the Forum of any but a Roman; some years later, however, another stranger, Hermodorus of Ephesus, a city of Greece, also received this honour. By his wise counsel he had aided the Romans in the making of their laws, and had thereby so gained their respect and admiration that they added his statue to the Comitium's monuments.

A few years before these laws were made, three Roman nobles had been sent as ambassadors to Greece, and while there they studied the government of that country. So when the citizens of Rome, tired of the misrule of the consuls, elected

in their places ten men known as decemvirs, they chose among them these ambassadors, and it was, perhaps, at their suggestion that the wise Hermodorus was invited to give them counsel concerning the arrangement of the laws. The decemvirs, after much consideration, presented to the people ten laws, to be obeyed by Patricians and Plebeians alike. And, that every one might judge of the fairness of these laws, they were written on tablets and hung in the Comitium for all to read. To these ten laws were soon added two others, and together they were called the Twelve Tables. These became the foundation of that marvellous system of Roman laws that to-day is part of every civilized government of the world.

The rule of the decemvirs, however, lasted but a little while, for the consuls were elected to lead the government, and the Plebeians were given special magistrates of their own called tribunes.

So Rome progressed, conquering her enemies, enlarging her boundaries, bettering her government. And then came days of humiliation, for the terrible Gauls overcame the Romans, and as victors entered the city.

When the people heard that the army had been

routed, and that the fierce Gauls were approaching Rome, their wonted bravery deserted them and they ran from before the enemy. They fled from the city, they, their wives, and their children, taking with them their household gods and whatever else could be carried in their haste.

But some of the ablest senators and a few of the strongest men went up into the citadel, which they stored with such arms and provisions as they could find; and here they determined to protect Roman honour to the last. So in all the city there remained only the aged men. For, too old to fight and too infirm to flee, what right had they to eat the bread needed by those whose arms were strong or to detain those whose feet were swift? But they could die nobly and without fear, like true Romans, and to this end each went into his own house, there to await the enemy and — death.

Then the venerable senators, arraying themselves in white robes, such as were worn by those that triumphed, and bearing all that marked their honourable office, proceeded to the Forum. They placed themselves on the Comitium, each in his ivory chair, each facing his doom with calm dig-

nity, as if to show that no terror was great enough to shake the government of Rome.

And so Brennus, at the head of his fierce barbarians, found them; and at the sight the wild hearts of the Gauls were stilled with a great amazement that was almost fear. For bravery needs no interpreter, and before them the bold invaders beheld a courage so great that they were overcome with awe. Clothed in skins, their rude weapons forgotten, these rough, unkempt men stood immovable, gazing with wonder upon the white-bearded old senators as they sat in their spotless robes, their ivory sceptres in their hands. In absolute stillness the venerable nobles looked upon the despised barbarians with scornful eyes that seemingly saw them not. Then a Gaul, bolder than the rest, came slowly toward one of these calm figures, and, leaning forward, plucked his beard to see if he were really man or not. Instantly the barbarian's head was struck with the senator's sceptre, and the curious Gaul discovered that Roman pride, when touched, made itself felt. Thus the spell was broken, and a great slaughter followed, in which no man was spared; after this the Gauls encamped in the

Forum and laid siege to the citadel above. This siege continued for many months, but at length the Romans were forced to make terms with their enemy. However, before the conclusion of the treaty Camillus and his troops came to the rescue of the citadel's little garrison, and the Gauls were forced to return without booty to their northern woods and fastnesses.

But Rome was left in ruins, and the people, coming back to find their homes destroyed or in ashes, determined to go to Veii, a conquered city not far distant, there to found a new capital for their nation. The wise Camillus did all he could to persuade them to be brave and not to desert the homes of their fathers; and so serious was the matter that the Senate met together in solemn consultation. While they were within the Curia, some soldiers, returning from relieving the guards, paused for rest on their way through the Comitium. The voice of their leader, as he bade his men halt, was clearly heard by the anxious magistrates in the Senate-house: "Standard-bearer, fix thy standard. It is best for us to stay here," were the words that reached them. With one accord the senators

took this as a good omen, and appeared in a body before the people in the Forum to tell them what had occurred. So the Romans remained, recovered their lost courage, and rebuilt their city.

In the long list of the chief places and buildings of Rome injured by the Gauls the name of the Comitium is not found. Perhaps the remembrance of the noble old senators' wonderful bravery caused the bold destroyers to respect this place, for, so far as known, its monuments and the Curia remained unharmed.

Not many years after the departure of the Gauls a tall column was placed on that side of the Comitium nearest the Tullianum, and almost on the Sacra Via, so that it stood at the entrance of the upper end of the Forum. It was called the Columna Mænia, or the Column of Mænius, and was raised after a victory gained in a battle on the sea, in which the commander of the Roman forces was the consul Mænius, whose bravery and good fortune were thus rewarded with public honour. For the Romans had not ceased to war with the tribes round about them, and had now conquered the Latins at Antium, one of the cities on the coast.

In this battle six of the Latin ships had been driven ashore, where they had been burned by the Romans, who, however, had saved as trophies the brazen beaks, or the sharp ends of the vessels' prows, which were ornamented with strange figures of men or animals, even as we sometimes see them on our ships to-day. These beaks of the vessels taken at Antium were brought back to Rome, where they were nailed to the front of a raised platform that stood on the Comitium, just before the Curia. This platform was used by the orators when making speeches to the people, and from the time that the trophies were added it was known as the Rostra, because "rostra" was the Latin name for "beaks."

The Rostra on the Comitium became the centre of those great struggles for liberty and for power that now stirred Rome for hundreds of years. At first the orators, when making their speeches, faced the Curia, for that was the stronghold of the Patricians; then, the Plebeians having become powerful, they turned to the middle of the Forum, the place of the people, as if addressing the ruling party.

Around the Rostra often stood excited crowds,

listening to burning words from this haughty Patrician or from that defiant Plebeian, whose sentiments were often repeated in such hostile tones by their friends among the throng, that persons of opposite opinions were moved with anger and replied with furious cries and blows. So it happened that among the quick-tempered Romans not only riots, but scenes of bloodshed, took place here again and again.

It was also upon the Rostra that the white-robed senators appeared before the people to announce some decision of the Senate or to explain some new law. Their speeches and those of the orators were thought to be of such importance that there was reserved on the Comitium a special place where, while waiting to be received by the Senate, strangers and ambassadors from other countries might listen to Roman eloquence. This place was an enclosed terrace near the Rostra, and was called the Græcostasis.

A noble stranger standing there might have spent many an hour in watching the busy Forum crowds, and in learning much concerning Roman ways. All about him on the Comitium told of Law and Justice. Within the Curia, the sena-

tors were considering the affairs of government;
on the Rostra, one of them was announcing a
decree to the multitude; near the Columna
Mænia, criminal cases, such as those of mur-
derers or traitors, were being tried; and nearer
the Græcostasis, less serious matters were being
brought before another tribunal. He might also
have noticed that the Romans paid due honour
to those that faithfully served the State, for many
statues and honorary columns were before him.
Close to the Rostra were the statues of four men,
and, in answer to his questions, he would have
learned that they were those of ambassadors once
sent to Fidenæ, a Roman colony then in revolt.
He might also have been told that they had met
their death by foul treachery, and that the sorrow-
ing people, at their own expense, had placed these
statues there. At each corner of the Comitium,
facing the Forum's centre, this stranger might
also have noticed a statue, and, had he happened to
have journeyed from the land of Greece, he would
have recognized the one as the figure of Pythago-
ras, a wise philosopher of his country, and the
other as that of Alcibiades, a most brave Grecian
soldier.

And had the stranger asked by what chance these statues of his countrymen had found a place in Rome's great Forum, he would have been told this story: While the Romans were at war with the Samnites, the Senate had sought and received directions concerning the welfare of the State from Apollo, the fair god who guides the chariot of the sun, and who is ever ready to aid all governments in time of trouble. By his command the statues of the wisest and of the bravest of the Greeks were to be erected on the Comitium, and this done, so the oracle foretold, Rome's standards would be raised in victory. And thus good fortune came to the Republic, and, moreover, a lesson was taught the Romans; for these silent figures of great men from another land seemed, not only to warn them against too much confidence in their own strength and wisdom, but also to teach them that they should profit by all that could be shown them by other nations. And, in truth, it so happened that Rome soon gained much knowledge from other peoples and that she tried her strength in many new ways.

For the Republic of Rome declared war against the Republic of Carthage, and the first battles

were fought on the island of Sicily, where the Carthaginians held large possessions. So it was necessary for the Roman army to be sent to Sicily by sea, and for the first time the cavalry, or horsemen, as well as the foot-soldiers, were carried across the water in ships. They went to victory, for the consul Valerius Messala, who commanded them, defeated not only the Carthaginians, but also their ally, Hieron, king of Syracuse, an independent city of Sicily. Much praise was awarded Messala upon his return to Rome, and he was permitted to ornament the porch of the Curia with a large painting of the battle in which he had been conqueror. And this, so we are told, was the first painting publicly exhibited in Rome. Later, however, pictures were often shown the people, and many of them were hung over the shops of the Forum, as when Mancinus showed and explained his painting of another victory over these same Carthaginians.

Valerius Messala made also another gift to the city, for he brought back as part of his booty something new and strange — something that the Romans had never seen before. This was a sun-dial, which he placed on a low column near

the Rostra, where it excited much interest and curiosity among the people. Until now the days of the Romans had been very simply divided as to time — the sun rose, and the sun set; it was day or it was night. At midday a crier, standing on the steps of the Curia, announced the hour of noon when he was able to see the sun between the Rostra and the Græcostasis; and he called out the evening hour when its last rays fell between the Columna Mænia and the Tullianum. But by the new sun-dial it was possible to tell one hour from another. To the busy people this made little difference — enough for them that the day passed away too soon — but to the many idlers of the Forum it gave never ending amusement. Through the long, sunny days these lazy ones used to linger about the Comitium, just to watch the shadow move across the dial, as Time, passing them by with empty hands, silently slipped away.

Thus from one of her enemies Rome gained the power of telling time; from another she now learned the art of building war-ships. For the Romans were not a seafaring people, and a few small vessels only had been needed for the defeat of the Latins at Antium; but in this war with

Carthage they were facing a foe of a very different kind. Always great merchants and traders, the Carthaginians owned large vessels and many mighty ships of war, and so were much more powerful than the Romans. But it happened that in a storm one of these Carthaginian ships was cast ashore upon the coast of Italy, and that the Romans, perceiving an opportunity to attack the Carthaginians after their own manner, hastened to profit by this chance. Using this wreck as a model, they laboured with marvellous rapidity, and in six weeks had fashioned one hundred and thirty great ships like those of their enemy. And while all this building was going on, no time was lost in other ways, for, within a large field, a rough frame was made in hasty imitation of a ship, and in it strong men were trained as rowers, and were made ready for the severe toil of the battles that were to come.

The first attempt of the Roman navy was unfortunate, for seventeen of the new ships were surprised and seized by the enemy; but the second venture was so successful that the unlucky event was forgotten. Under the command of the consul Duilius, the rest of the war vessels met

the Carthaginian fleet near Mylæ, a town on the coast of Sicily, and gained a great victory. Fourteen of the enemy's ships were destroyed, and thirty-one of them captured.

To the consul Duilius alone was due all the glory of this success, for it was by the use of a new implement of war, invented by him, that the famous day was won. When Duilius had received orders from the Senate to command the fleet, he pondered long as to the best means of conquering the enemy; for the Romans were ignorant of naval matters, and he knew that the Carthaginians were as great masters in the art of warfare upon the sea, as they themselves were in that upon the land. One thing, however, was clear to him — the nearer an encounter on the water could be made to resemble a fight on land, the more victorious would be his forces; and, at last, he conceived a way to accomplish even this. To the fore part of each of his ships he attached a boarding-bridge, a ladder-like affair that could be swung out from the vessel, and that had on its free end huge grappling-irons or spikes, which were let down or were pulled up by ropes. Thus, when one of the enemy's ships came near enough,

a bridge was swung out, and allowed to fall upon the deck of the hostile vessel, where it became fastened by means of the iron spikes. This done, the Romans poured over the bridge, and a hand-to-hand fight took place, even as it would have done upon land. So instead of battering into their foe, as was their custom, the ships of the Carthaginians were either broken in two, or were held fast by these new bridges, while hundreds of their sailors were slain by the veteran soldiers of Rome.

Thus Duilius won the day at Mylæ. And, in their gratitude, the Romans vied with one another to do him honour. He went in triumph through the city; and, as a continued honour, he was permitted the escort of a torch-bearer and of a flute-player whenever he returned at night from banquets or grand entertainments. And on the Comitium, near the Rostra, was erected a large column, ornamented with some of the beaks of the Carthaginian vessels. This was long pointed out as the Columna Duilia, or the Column of Duilius, the victorious commander of the Roman navy during its first battle.

The Romans warred with the Carthaginians for

many long years, but in the end they were completely victorious; and, although the expenses during that time had been heavy, prosperous days now came to Rome, whose coffers were overflowing with Carthaginian gold. Wars with other nations, however, were still carried on; but an unusual disturbance within Rome itself suddenly turned the attention of the Senate and of all the magistrates from foreign to home affairs.

The matter was strange, unheard of. Nothing like it had ever happened in Rome before. The city was full of excitement; the affair was talked of everywhere. Rich and poor, high and low, discussed the subject with the greatest interest; sides were strongly taken, and, so intense was the feeling, that almost each household was divided against itself.

The centre of the excitement, however, was the Forum, and on and about the Comitium the crowds, for days together, were very great. The Senate sat in anxious consultation, wise magistrates advised this way or that, men of influence gave their opinion for or against the matter, and all Rome was in a ferment. And for what reason? For what grave cause did Rome forget that she

was at war, and that the fate of nations hung in the balance? Because the matrons of Rome, wishing to wear ornaments of gold and garments of richness, were demanding the repeal of a law which, during the Carthaginian wars, had forbidden them such luxuries. This was called the Oppian Law, because it was brought before the Senate by the Tribune Caius Oppius, and these were the words thereof: " No woman shall possess more than half an ounce of gold, or wear a garment of various colours, or ride in a carriage drawn by horses, in a city, or in a town, or in any place nearer thereto than one mile; except on occasion of some public religious solemnity."

Now while the Republic had been at war, both public and private money had been needed for its expenses, and the Roman women had not complained, but rather had taken pride in giving their share toward the fund in the Treasury. But the long war was over, and Rome's coffers were full — was it then just, they asked, that they should continue to wear plain, dull-coloured robes, and be unadorned with their accustomed ornaments? Should the women of their vanquished enemies be more richly clothed than they, the wives and

daughters of the conquerors? This was, indeed, a dishonour to the nation. And in their determination to have this matter righted, the matrons came into the Forum in immense numbers, beseeching the senators to repeal the odious law, and in every way endeavouring to obtain for their cause the votes of those that were to decide this important question. There were women everywhere; they filled the streets, they stopped the men on their way to business, they gave the magistrates no peace. Now this was contrary to all custom, for the Roman women never appeared in public affairs, and their present action was shocking to those that beheld it. The consul Cato denounced their behaviour in a speech in the Curia, and said that he was ashamed of the women of his city. But another magistrate, the tribune Valerius, took the matrons' part, and, also in a speech, recalled to the minds of the senators the many ways in which, in past years, the Roman women had nobly assisted the State, and had willingly given up their gold in the time of the nation's need. He insisted upon the righteousness of their present demand, and said that the men of Rome should be proud to have the

attire of their wives and daughters equal and even excel that of the women of other nations. At last, his words, and the incessant pleadings of the matrons, gained the day. The hated law was repealed, and thenceforth the noble ladies of Rome appeared in the garments and the ornaments that befitted their honourable station.

In truth, Rome, strong in conquest, rich in possessions, and famous through the deeds of her great men, now took a place among the leading nations of the world. The Comitium, and, indeed, the entire Forum, became so crowded with the statues of her heroes that the Senate was forced from time to time to remove many of these images, in order to honour men of more recent fame. About this time, however, there was raised, near the ancient fig tree, a certain statue that remained on the Comitium for several hundred years. The figure was that of a man bearing on his shoulder a full wine-skin, and holding one of his hands uplifted, as if to bespeak the attention of the passer-by. This statue was that of Marsyas, an attendant of Bacchus, the ivy-crowned god of freedom and plenty. With its raised hand, the image of Marsyas seemed to bid men stop and

ponder upon the freedom gained through the just dealings of the law, and upon the plenty of a land where the people were so wisely governed. Therefore this statue stood as a symbol of happy liberty, and as such was also placed in the forums of many towns under Roman rule. It became a custom for successful lawyers to crown Marsyas with a chaplet of flowers; for truly, were not the minds of their clients freed from anxiety, and had not they themselves gained full purses? And once when in sport a young man stole one of the garlands of Marsyas, he was made to suffer imprisonment, so highly was this statue honoured and cared for.

But, alas! the Romans were not long at peace either at home or abroad. Their riches and successes were already proving a curse. The people cared but for games and amusements; the government but for conquests and triumphs. The influence of the Senate lessened as that of the army increased, until Rome's real rulers were the most popular and powerful generals of her military forces. So the time came when her greatest foes were those within her own walls, and when she received blow after blow from those whose duty it was to uphold and to protect her.

Two of her consuls, great generals, but envious
and ambitious men, used their honourable trusts
as the means for their own success, and fought
their way to fame and wealth over downtrodden
law and murdered men. The names of Marius
and Sulla are even now spoken with horror by
all that know of the sufferings of the Romans
under their lawless rule. For the city now
saw days of strife that made the struggles
of the Patricians and the Plebeians seem as
nothing.

Wars with other nations were almost forgotten
during the bitter contest of these two men, each
of whom, striving to gain the highest authority
and holding might as the only form of right, used
all and any means to serve his ends. Rome was
in the hands first of one party, then of the other;
riots and murders followed in quick succession;
the Senate bowed down to whomsoever was
master of the hour. An army, led by Sulla,
came as an enemy against Rome herself, and
within her very gates battled with the forces of
Marius. Roman against Roman, and the govern-
ment in the hands of the stronger! Was this the
great nation whose men had been known as among

the bravest and the most loyal of all the world?
Were these the descendants of such stanch up-
holders of the Republic as Brutus, and Cincinna-
tus, and Camillus? No wonder that Scipio
Æmilianus, another of Rome's great generals,
changed the prayer by which the magistrates
were wont to petition the gods! No wonder
that, foreseeing the troubles of his country, he had
not prayed, "May the State be increased!" but
had uttered instead the sad entreaty, "May the
State be preserved!"

Of these hard and bitter rivals, Caius Marius
was the elder. He was made consul seven times,
yet he died a miserable, disappointed man, be-
cause, although having all that wealth and posi-
tion could give, he had not obtained the command
of a certain coveted campaign, and had been
forced to see Sulla triumph in his place. Never-
theless, in his day he gained great glory; but it
was dearly bought with human life — not only
with that of the soldiers, but with that of any
person, high or low, who stood in his mad ambi-
tion's way. For at one time, by the order of
Marius, the gates of Rome were closed, and for
five days the merciless tyrant went about the city

with a band of armed men that killed on the spot whomsoever he pointed out. And to serve him, or to be his friend, insured no measure of safety, for he aided none and used all.

During a certain turmoil in Rome, Saturninus, Glaucia, and Saufeius, base magistrates and associates of Marius, were obliged to escape from the attacks of the furious multitude by taking refuge in the Capitol. At last, however, the three desperate men gave themselves up to Marius, then consul for the sixth time, for they hoped that he would use his power in their defence. But they trusted him in vain, for, ordering them to be shut up in the Curia, — as if placing them under the protection of the law, — he abandoned them to the mob, which, pulling the tiles off the roof of the Senate-house, stoned them to death.

And it was in the time of Marius that the horrible custom began of hanging the heads of murdered men on the front of the Rostra. The first victim whose head was thus shown to the people, was the consul Octavius, basely killed because he refused to desert his office and leave Rome to Marius and his followers. This Octavius was the second of his name whose life was

taken while in the service of his country. And near the Rostra, to which was attached his bleeding head, stood the statue of Cneius Octavius, his grandfather, treacherously murdered while on an embassy to the land of Syria.

It was also by the order of Marius that the orator, Marcus Antonius, was tracked to his place of hiding in a farm-house, and there killed; for he had used his eloquence in Sulla's favour, and was too dangerous an enemy to be allowed to live. But so great was his power that the very men who came to kill him were charmed by his words, and forgot their hideous errand as they listened to the speech he made them. And thus spellbound, a tribune found them when he came to make sure that the deed was done, and that this enemy of Marius was quieted forever. Amazed at the sight, and angered at the delay, the tribune with his own hands cut off the head of Antonius, even as the great orator was still addressing the men. Then, with a severe rebuke for their weakness, he bade the assassins take the head to Marius, who caused it to be hung among the other horrible trophies of the Rostra.

The end of Cornelius Sulla was very unlike

that of his enemy, for he died satisfied with all that he had done, and believing himself to have been favoured by the gods above all other men. At the height of his success, some years after the death of Marius, Sulla became dictator for life, and in a speech to the people he spoke of his unvarying good fortune, and claimed for himself the title of " Felix," or the " happy one." Soon afterward the servile Senate placed near the Rostra a gilt statue of Sulla, mounted upon his charger, and on the base were inscribed these words, " Cornelius Sulla, a fortunate Commander."

Romans of all ranks now acknowledged this man as their master, but their homage was that compelled by terror, not that of respectful admiration. For when Sulla became the chief magistrate, he determined to destroy all persons belonging to the family of Marius, together with all the members of his party, and to this end he drew up a long list of such as were to be put to death. This list was attached to the Rostra in the sight of all the people, and was called a " Proscriptio," or a " writing up." Besides the names of those that were condemned by Sulla, because " enemies of the State," there were mentioned

in the proscription various prizes to assassins and rewards to all informers. This proscription was the first in the history of the Romans, but even in the time of Sulla there were many others. To oblige his friends, he often added the names of their enemies to his awful lists, and no man was safe at any time. Spies were everywhere, and people, taken unawares, were killed in their homes, in the streets, and even in the temples. The old writers tell us that fifty senators and one thousand nobles died by the order of Marius, and that forty senators and one thousand and six hundred nobles were the victims of Sulla. Thus none were left to gainsay him, and this great and terrible man became absolute master of Rome.

And then, having reached the summit of his ambition, Cornelius Sulla summoned the people to the Forum, and from the Rostra made a speech that filled them with astonishment. He told them that it was his purpose to lay down the dictatorship, that he was about to retire to the enjoyment of private life, and that from that day he left them free to elect whom they would as their magistrates. And he followed this astounding speech with an act of still more sur-

prising boldness. Discharging his armed attendants, and dismissing his lictors, he descended from the Rostra, and passed through the crowd like an ordinary citizen, a few friends only accompanying him to his home. The amazed people, who had every reason to hate him, and to wreak vengeance upon him, let him go unharmed, and even looked upon him with awe, for his courage was indeed magnificent.

Sulla gave the Romans a grand farewell feast, and then left Rome for his estate in the country. There he remained until his death, one year later, spending his days in revelry and pleasure, and yet finding time to finish the history of his life, wherein he describes himself as "fortunate and all-powerful to his last hour."

While he was dictator, Sulla not only changed the laws to suit his own purposes, but he also altered the house of the law-makers. He both improved and enlarged the Curia, and in so doing, the old statues of Alcibiades and Pythagoras were taken away to make room for the more spacious building. And about this time the Curia was adorned with another painting, one brought by the magistrates, Murena and Varro,

from Lacedæmon, a city of Greece. Now this
work of art was very curious, for the picture,
having formed part of the decoration of a wall,
the plaster on which it was painted had been
carefully removed, and carried to Rome protected
by wooden frames. The Romans looked upon
the picture with great interest, admiring it as
much for the skill by which it had been brought
so far, as for the beauty of the work itself.

Yet another work of art was added to the
Comitium by Lucullus, who led the Romans
against Mithridates, king of Pontus, a country
of Asia Minor. As a part of his great spoils, he
brought back to Rome a statue of Hercules, the
mighty conqueror, before whom all triumphant
warriors rendered their thank-offerings. And on
the Comitium, near the Rostra, this statue was
placed as a fit symbol of the strength and the
success of Roman arms.

But although the Romans had formed a taste
for art, and their houses were now made far less
simply than before, the chief building of the
government, the Curia, still remained severely
plain. And the spirit of the senators was in
accord with their building, for, in a letter to one

of his friends, Cicero, the famous orator, tells of
their great frugality. No matter how cold the
weather, so he writes, the senators had no fire in
the Curia, and once, upon a bitter winter's day,
when they had met on a matter of special impor-
tance, the Speaker was forced to dismiss the
members, the chill being so great that none could
bear it. So the senators left the Curia, to the
vast amusement of the people, among whom
even the farmers had fires to heat their homes
during the cold days of the winter.

Now this same Cicero, Rome's most able
orator, was an honest man, a great patriot, but,
withal, a determined enemy; and as he denounced
his opponents without mercy, even so was he
deeply hated in return. During his entire life-
time Rome was disturbed, divided between sets of
men whose leaders schemed continually to over-
throw the Senate, and to form a government of
their own. Riots occurred day after day, and
more than once the Forum was red with blood.

At one time Cicero was forced to leave Italy
because of the evil designs of one of his adver-
saries, the tribune Clodius Pulcher, a bad, mali-
cious man. And while the great statesman was

in exile, Quintus, his brother, returned to Rome
from the province of Asia, over which he had
been governor for three years. He was met by
many citizens belonging to Cicero's party, and,
at their suggestion, promised to appear in the
Forum to entreat the men of Rome to recall his
brother. But when he arrived at the Rostra by
dawn of the next day, Quintus found the Comi-
tium and the Curia already in the possession of
men sent by Clodius. Before he could utter a
word, he was dragged down from the Rostra, and
a violent fight took place between his followers
and the armed men and slaves of Clodius. Many
were slain, still more were wounded, and Quintus
himself saved his life only by hiding beneath the
corpses that were lying in heaps about the place.
On that awful day the Tiber was filled with dead
bodies, the great sewers were choked, and the
blood was wiped up from the Forum with large
sponges.

Yet so hardened were the hearts of the Romans,
and so used were they to the horrid sight of
human blood, that when two citizens arrived in
the Forum after this terrible slaughter, they
looked unmoved upon the scene and upon the

blood that ran freely in the gutters, and calmly said, the one to the other: —

"Surely, many gladiators have fought, and a show of great magnificence has been held! No Plebeian entertainment was this, but a celebration by a magistrate or a Patrician of high rank. Whose think you may it have been?"

Within a year, however, Cicero's fortune changed, and he was called back to Rome, where he was received with much rejoicing, and where he lived to see the downfall of his foe. For Clodius, although the favourite of the mob, had many enemies, chief among whom was a tribune named Milo, a man who, for his own advancement, had taken sides with Cicero. Both Clodius and Milo, as they went about the city, were constantly attended by bands of armed ruffians that attacked one another in the streets, in the Forum, or wherever they happened to meet. For the government was crushed, the Senate was helpless, and there were none to enforce the law. Rome was without a master, and Justice had fled before unchecked Crime. At last one day, as Clodius was returning to Rome, and Milo was leaving the city, they passed each other on the Appian Way, a road leading

out into the country. A fray followed in which Clodius was killed; and his body, left in contempt on the spot where it had fallen, was found by a senator, who caused it to be carried to Rome and placed on the Rostra. Indignant at the death of their favourite, the people gathered about in wildly excited throngs, while those magistrates that were on the side of Clodius made fiery speeches to the already maddened multitude. Then the people rose in a fury, and bore the corpse into the Curia, that it might lie in state in the very highest place of the government, and thus the Senate be insulted and defied.

And then, their rage waxing even greater, the most reckless of the mob gathered together the benches and the desks of the Curia, and made of them a funeral pyre. Upon this they placed the body of Clodius, and, amidst frantic cries, set the pyre in flames; whereupon the crowds rushed forth into the Forum with the wildest shouts of exultation.

With the burning of this wretched man's body, the old Curia Hostilia was destroyed, as were several other buildings. Thus, in the fire of lawless tumult, fell the ancient government of Rome;

and thus, in the ashes of disgrace, ended the Republic. The State gave way to the statesman; the rights of the people became second to the glory of the ruler; for when the Senate-house was rebuilt, it bore the name of Julius Cæsar, Rome's greatest master, and within the new Curia Julia, the senators met but as the servants of the emperor.

To mark the difference between the order of the government that had been and that which was to come, Julius Cæsar planned many changes in the Forum. One of the chief of these was the removal of the Rostra from the Comitium to the middle of the Forum at its upper end. There it was still the platform of the orators and the magistrates, but before long it became the throne on which the emperors appeared before the people.

The old statues that had stood near the Rostra on the Comitium were now placed beside it in its new position. To these were added others, among which were two statues of Cæsar himself, and one of the young Octavius, who became Rome's first emperor and received the name of Augustus, the Exalted.

The treacherous murder of the great dictator left his affairs in the hands of his adopted son,

and thus it was Augustus that carried out Julius
Cæsar's plans, and that finished the new Curia.
To this was now added a chalcidium, or sort of por-
tico, and the building was made larger and more
beautiful than ever before. Within, Augustus
ornamented the walls with two paintings by fa-
mous Greek artists; and in the centre of the Curia
he placed a bronze statue of Victory, the goddess
of Success, whose shining wings bear her above
all difficulties, whose uplifted head is crowned
with the wreath of triumph, and whose hands
hold, not only the palm branch of the conqueror,
but also the magic wand of Mercury. For Mer-
cury, the messenger of the gods, had received
this wand from Apollo, the protector of nations,
and by its virtues all disputes were settled and
the bitterest of enemies reconciled. And thus,
as a herald of good news, Victory announces
peace as well as triumph. At the base of this
beautiful figure, erected in memory of his great
victory at Actium, the emperor placed some of
the spoils brought from Egypt, and in this man-
ner constantly reminded the Senate that he had
conquered, not only her enemies, but Rome
herself.

Before this statue an altar was made in the Curia, where for centuries this goddess was worshipped by the Roman people. The fire in the time of the Emperor Nero greatly injured the Senate-house, but the Victory was saved from the flames, and was replaced in this building when restored by the Emperor Domitian. Many years later, the Curia again suffered from a fire that occurred during the reign of the Emperor Carinus. But it was rebuilt by the Emperor Diocletian, and within this last Senate-house the ancient statue still guarded the weal of Rome.

Now when the emperors became Christians, some of the nobles adopted the new religion, although many remained steadfast in the worship of the ancient gods of Rome. But little by little the Christian party grew to be the stronger, and slowly the gods began to be forgotten. During the reign of Emperor Valentian, however, there arose a strong champion of the old faith, for the offices of pontiff and augur were held by Symmachus, a noble senator. He came before Valentian to ask for the restoration of the altar of Victory in the Curia; for Gratian, the last emperor, had forbidden the rites, and had

had the statue removed. Symmachus, a man of rare eloquence, pleaded for freedom to worship the goddess of Rome's government, and he would have persuaded Valentian to grant his request had it not been for Ambrose, the archbishop of Milan, one of Italy's most important cities. This Ambrose was not only a Christian, but a great scholar, and so firm a defender of his religion that he became known as one of the " Fathers of the Church." And now, with words of deep wisdom, he showed Valentian that Symmachus was eloquent but unwise, and that old things must pass away and new ones take their places. So he convinced the emperor, and from that time the statue of Victory was no longer worshipped. A few years later, the doors of all the temples were shut by the Emperor Theodosius, who drove through the city in triumph, while at his chariot-wheels the gods of ancient Rome were dragged through the dust.

So the Christian religion won the victory, and in after years the Curia itself was changed into a church. And to-day in S. Adriano in Rome may be seen some parts of the old Senate-house of Diocletian — a fragment of the glories of the

Empire, and a faint reminder of the strength of the Republic.

The importance of the Comitium became less from the time that the Rostra was moved away; trials were carried on elsewhere, famous men were honoured in the new forums, the Senate met in other places, and its renown was gone forever. And even from the days of the Emperor Severus, men spoke of the ancient centre of the government as of something belonging only to the past. For Rome's law, given to her conquered lands, left its birthplace to go out into all the civilized world, and although called Roman law, it was no longer known as the law of Rome.

IV

"Look once more, I pray thee! Doth no one come?"

"None."

"How late is it?"

"The red lights of the sky fade over the farthest hills."

"Hearest aught of fighting?"

"Fighting? Thou foolish woman! The Romans fight no longer. They know not how, since Romulus has gone from earth. Now, men but bend the knee, and whisper prayers, and go about like very women. Fighting? no such glad sound. The air is peaceful save for the talk in the market-place. The people are still there, for the king is met with his council on the Comitium and has been there since the sun passed the mid-heaven."

"Ah! that it is then that keeps Orius!" exclaimed the first speaker, coming to the doorway of a hut built at the edge of a deep, dark forest, on the side of a gently sloping hill. Near her, upon a low, flat stone, sat an aged man, leaning forward upon his staff, and gazing down into the valley before him.

"Yet I would he came quickly!" sighed the woman. "The fagots are laid, the meat hangs ready, the cakes are formed, and I am greatly hungered."

"Doubtless the king has bethought him of something new, — would build yet more houses, or perchance, would tell us to worship yet another god," grumbled the old man who had fought under Romulus, and to whom the ways of King Numa seemed both weak and unworthy. "Thy husband, Macolnia, is too busy with the foolish plans of Numa to bring thee the fire to cook thy evening meal. Thou and I must starve at his will."

Macolnia's lips parted in quick reply, then she closed them firmly, and a silence fell between the two. She would fain have defended Orius, who was a senator of Rome, had not the words been

spoken by Abarus, her father, and a brave warrior of great renown.

So they kept speechless watch amid the deepening dusk, until, upon the path that led up from the valley, there suddenly appeared a tiny, dancing light; and soon the form of a strong man came into sight. He was running, and in one hand waved aloft a blazing brand just taken from the public fire of the market-place.

"Greeting, Macolnia! Hail, Abarus!" cried out the newcomer; "I sorrow that I come late, but much business hath delayed me." And without further word of explanation, Orius hastily entered the hut, approached the hearth, and set fire to the carefully piled up fagots. Then he passed out to the spring near by, and while he refreshed himself with its cooling waters, Macolnia prepared their simple meal. And, wise woman that she was, she did not speak again until the men's hunger had been satisfied.

"And thy business, Orius," asked she, gently. "Is it aught concerning which we may know? or was it but affairs of state?"

"Nay, gladly will I tell thee," replied Orius, "although 'tis naught that will please the ear of

Abarus! The good Numa hath opened our eyes to a new wonder, and hath shown us yet again how beloved of the gods are the Roman people. Seest thou the flame of yonder fire? 'Tis sacred! 'Tis the sign of Vesta, the goddess of the hearth; so Numa hath indeed taught us to-day. And the hut in the market-place shall be henceforth holy, and shall be made into a temple."

"Ah! said I not so?" cried old Abarus. "Another god! more priests, less soldiers! more doings of women, less doings of men!"

"This time thou art right, Abarus," laughed Orius, "for the guardians of the sacred fire are to be maidens, four in number. Numa himself hath chosen them from among our best and fairest — Gegania and Verania, Canuleia and Tarpeia."

"Well chosen!" cried Macolnia, "and a noble worship. Let us even now pour out a libation on the hearth, that our home may be among the first to receive Vesta's blessing."

And this they devoutly did, even Abarus bending before the bright flame, leaping up as if in answer to their prayers.

Now Macolnia, Abarus, and Orius were not real persons, being only people in a word-picture,

showing somewhat of life in the days of the early kings; but Gegania, Verania, Canuleia, and Tarpeia, according to the writings of the old historians, were the true names of the four first priestesses of Vesta. And thus it was that Numa founded the worship of this goddess among the Romans, and taught these warlike people the ways of peace. So the thatched hut of the market-place became a hallowed spot, and the most sacred of all the shrines of Rome.

Next to the temple, Numa soon built a home for the priestesses of Vesta, and this house was called the Atrium, because in its centre was such a very large, open court, or atrium, that it gave its name to the entire building. And close beside the Atrium, Numa also built the Regia, or the king's house, where he lived, not only as ruler, but as the first Pontifex Maximus, or High Priest. Now the Pontifex Maximus was the chief director in all matters of worship, and under his special care were Vesta's maidens, whose number was increased to six by King Servius Tullius. By a decree of Numa, these priestesses were supported by money from the public treasury, and, that nothing should turn their minds from their duties

to the goddess, they were forbidden to marry while in her service; for this reason they were called the Vestal Virgins.

For a term of thirty years the Vestals served their gentle goddess, and a new priestess was chosen only upon the death of one of their number. When it became necessary to elect a Vestal, there was much interest throughout the city, for the Pontifex Maximus, naming twenty little girls, over six yet under ten years of age, summoned them to the Forum, where a choice was made by drawing lots. The young candidate had to be perfect in mind and body, fair to look upon, and sweet in spirit. She was chosen from a family of high rank, her father and mother being both alive at the time of the election, and the record of their days being as honourable as that of their station.

Many persons, doubtless, came into the Forum when a Vestal was to be chosen, for the sight of the winsome children must have made a goodly picture indeed, delighting the eye and gladdening the heart. Sometimes it so happened that a father, of his own accord, offered his daughter as a priestess to Vesta, and, if the maiden satisfied all demands, she was at once accepted; but

146

the usual custom was the selection of one from among the twenty little girls. The choice made, the Pontifex Maximus took the hand of the tiny maiden, and spoke to her a few solemn words concerning the grave duties upon which she was to enter, and at the end he gently said, "I take thee, Beloved." And from that moment she was no longer a member of her own family, but belonged to the sacred sisterhood of Vesta, over whom the High Priest watched with a father's protecting care.

After this simple ceremony the new Vestal was led into the Atrium, and there the childish curls were cut off, and the head of the little priestess was bound with a white fillet, or band of ribbon, which was twisted about a lock of wool, symbol of holy office. The locks of her own hair were hung upon a sacred lotus tree that stood in the Grove of Vesta, a garden belonging to the Atrium, and on the slope of the Palatine Hill. All this was done according to an ancient custom, for the cutting off of the hair was a sign of submission — as when the hair of captives was cut off by their conquerors — and now this young maiden belonged to Vesta, to whom she was in all ways

to submit herself. Her hair was hung on the
lotus tree as a further sign that a change had
come into her life, and that she had given her-
self entirely to the service of the goddess. The
little girl was then clothed in the white robe of
the Vestal, after which she took a solemn vow
to obey Vesta, and to guard faithfully the wel-
fare of Rome. Doubtless the child did not
understand the words that her lips uttered, but
there was plenty of time to learn their mean-
ing, for the first ten years of the new Vestal's
life were spent in gaining the knowledge of her
duties and of the form of worship by which the
goddess was approached. During the next ten
years she practised these duties, and in the last
ten she gently taught them to the young priest-
esses, even as she herself had been carefully in-
structed. At the end of those thirty years, the
Vestal was free to return to her home, to marry,
or to lead whatsoever manner of life seemed to
her best; but so happy and content were the
days spent in Vesta's pure and simple service,
that few of her priestesses took advantage of
their liberty. They chose the peace and honours
of the sisterhood, rather than the trials and uncer-

tainties of the world. For all was calm and lovely in the home of Vesta's virgins, where the child-Vestal was called " Amata," the " Beloved," and where the oldest among them was affectionately revered as the Vestalis Maxima, the greatest or most honourable of the Vestals. It was she whose fillets were the most twisted, for the Vestal's hair was not again cut, and was always bound with the fillets, the number of whose twists marked the degree of dignity to which the priestess had attained.

The first and chief duty of the Vestals was the care of the ever burning fire of the Temple, wherein was no statue of Vesta, but where the bright flame upon the altar alone showed her presence to all faithful worshippers. And when, from want of care, or for any other reason, the sacred fire died out, the hearts of the Romans were sorely troubled; for they believed it to be a sign that the goddess, in displeasure, had deserted them, and that the city was menaced with the greatest danger. Thus Vesta was worshipped as the guardian of Rome's welfare; for was not the city the home of the nation, and her temple the hearth of the entire people? Just outside the

Temple, however, there was a beautiful little shrine in which stood the image of Vesta, and here the Virgins offered sacrifices of cakes of salted meal, and poured out libations of oil or wine.

The second duty of the priestesses was the bringing of pure, fresh water for use within the Temple. It was taken from a sacred spring that rose cool and clear, in the depths of green woods just beyond the city's walls. In this shady dell once lived a nymph, named Egeria, whose wisdom was very great; and her story has been told by one of the ancient poets in this wise: —

The special guardian of the bubbling springs and flowing fountains was Egeria, an attendant of Diana, the fair goddess of the Moon. Now Diana's most loved earthly homes were in the shades of deep forests, beside sparkling brooks and lakes; therefore she held Egeria in much affection, and when a heavy grief befell the nymph, the goddess used all her power to bring her comfort. For Egeria had been sought in counsel by Numa, the king, and had taught him many things, — how to soften the hearts of the warlike Romans, how to worship the gods, and how to govern the people. Through all his

long reign the wise nymph aided Numa, and her
heart also went out to him, so that when he died
she wept, inconsolable. Throwing herself at the
base of a little hill in her deep grove, she dis-
solved into tears, until, moved by her great sor-
row, the pitying Diana formed of her a fountain,
from which came ever flowing waters.

And so, according to the fable, the water used
in Vesta's Temple came from the pure spring of
Wisdom. Be this as it may, the water used by
the Vestals was fresh and sweet, and with it the
sacred place was daily sprinkled, in token of the
cleansing, not only of the Temple, but of the city
also.

The Vestals used a branch of laurel wherewith
to sprinkle the Temple, which they also kept
adorned with the ever green boughs of this tree.
The story of the laurel has also been written by
the same poet that has told about Egeria, and
from his words may, perhaps, be learned why
this tree was employed in the service of Vesta.

There was once, so the story runs, a fair virgin,
named Daphne, who was beloved by the god
Apollo. But as her heart was untouched and
she would marry no one, she fled from the god,

who, however, followed in hot pursuit. In her swift flight, Daphne reached the bank of a deep river, and as she stood by the water's side, uncertain which way to turn, hope sank within her, for she saw Apollo fast approaching. Then, in despair, she prayed aloud for help to Peneus, the god of that river, and immediately she was turned into a graceful tree of laurel. When Apollo reached the spot, the leaves were still trembling, but Daphne was no longer to be seen. Then the god said, "Since thou canst not be my wife, thou shalt be my tree!" And thus Apollo's hair is crowned with laurel, and his lyre and his bow are made of its wood.

So seems it not meet indeed that the laurel — the "virgin's tree," made sacred by Apollo, the god of celestial fire — should be used in the Temple of Vesta, the virgin-goddess, whose emblem was the never dying flame?

On the first day of March of every year the Vestals gathered fresh laurel, and wreathed the Temple with new foliage. On this day also the sacred fire on the altar was extinguished by the Pontifex Maximus, and then relighted by him with solemn ceremonies. For the first of

March was the New Year of the Roman religion;
at that time all things began afresh, — the world
was wakened by the sunshine of Spring, and
man, casting aside his past, prayed for a renewal
of strength within his soul. In the early times,
the High Priest relighted the fire simply by
rubbing two bits of wood together until they
glowed; later, however, he used a glass through
which the sun's rays were focussed to the burn-
ing point. Thus Vesta's fires were never lighted
from any other, and only flamed by heat obtained
directly from earth or from heaven.

At this time fresh laurel was also placed on
the Regia, within which were two chapels, one
to Mars, the god of War, and one to Ops Con-
siva, a goddess of Plenty. Before the entrance of
the chapel of Mars grew two laurel trees, and it
was from these, they say, that the Vestals took
the boughs with which their temple was adorned.

Within the Regia, where the pontiffs held
meetings on matters pertaining to religion, were
kept many priestly records of great value; but in
the care of the Vestal Virgins were things far
more precious — things on which the fate of the
nation itself depended. These most sacred treas-

ures were guarded in a shrine built in the centre
of the large court of the Atrium; and this Holy
of Holies of the Roman people was called the
Penetralia, or innermost sanctuary of Vesta. No
man, save the Pontifex Maximus, was permitted
to enter this hallowed place; and only once a
year, at the Vestalia, or festival of Vesta, were
any women, other than the priestesses, allowed
to pass the sacred threshold.

The holy objects were guarded with such
caution that they were kept in an earthen jar,
closely sealed and placed by the side of one
exactly like the first, but empty, so that only the
Vestals and the High Priest knew which of the
two held the "sacred things." Indeed, such deep
and awful mystery surrounded these objects that
even the Romans themselves did not know what
they were. They believed, however, that the
most holy of the treasures was a small statue,
called the Palladium, and that by its virtues
the city in which it was kept could never be
conquered.

It was a statue that had fallen from heaven
itself, and this, so the old legend goes, happened
in the times when men were few upon the earth,

and when the gods were mighty upon Olympus, their celestial home. In those days of wonders was born Minerva, Jupiter's wise daughter, who, full-grown and clothed in shining armour, sprang into life from the head of her mighty sire. Her birthplace was near a certain rushing river, where lived Neptune's son Triton, and where for many years she remained in the care of this river-god, enjoying the companionship of his fair daughter Pallas. Now both the maidens, as strong as they were beautiful, delighted to make trial of their power, and one day as they wrestled in friendly contest, Jupiter appeared in the clouds above their heads. Fearful lest his favourite child be overcome, he held forth his glittering shield to attract the attention of Pallas. So bright it gleamed, the maiden could not choose but look, and at that instant Minerva dealt a hard blow that caused fair Pallas to fall dead at her feet. Then the goddess in deep sorrow made an image of Pallas, which she placed beside the statue of Jupiter himself. Not long after, it happened that the god was angry, and that he took up this image and hurled it downward to the earth. It fell at the feet of Ilus, one of the

ancient Greeks, just as he was praying for a sign from heaven to show where best to begin the city that he purposed building. Reverently accepting this marvel as an answer to his petition, he enclosed the statue in a shrine, and about that place began to found the city of Troy. From that time men came to believe that the sacred image insured the safety of the city wherein it was kept. Brought by Æneas into Italy, it was given later into the care of the Vestal Virgins, who kept it as a pledge of the gods for the welfare of Rome. The Romans called the image the Palladium, a word even now used to mean that which is a protection or security. This figure, men say, was of wood, and was that of a woman, whose long draperies reached her feet, whose right hand held aloft a spear, and whose left carried a spindle and a distaff. In time, not content to believe this marvellous statue to be only that of Pallas, the daughter of Triton, men would have it instead that of Minerva herself, who in other lands was often called Pallas — but whether the image was that of the fair maiden, or of the wise goddess, none may know. For the gods have disappeared

into the darkness of the Long-Ago, and in the bright light of To-day one can only guess at their faint shadows that flicker and change even as one looks upon them.

Beside the sacred things, the Vestals had also in their care some holy objects that were used in the great festivals of other deities; for these priestesses were highly reverenced, and whatsoever passed through their pure hands was held doubly sacred. Thus they took part in all important religious ceremonies, and it was also one of their duties to prepare the *mola salsa*, or salted cake, so often used as a sacrifice. Everything concerning the making of these cakes was exceedingly fresh and clean, and it was done in a simple manner, after very strict rules. The Vestals prepared the salt in a special way, pounding it to powder in a mortar; and in the springtime they themselves plucked the first ears of the early corn, which they dried and ground to finest flour, carefully kept within the Penetralia. So the worship of Vesta sanctified the flour of daily use, and for this reason all the millers and bakers kept holiday at the time of the Vestalia. This festival began on the seventh

157

of June, and lasted seven days. The work of the mills was stopped, and all the patient beasts that turned them were allowed to rest; the donkeys were gayly dressed with wreaths of flowers, and around their shaggy necks were hung necklaces of pretty cakes and of loaves of bread. The millers placed garlands on their mills; the bakers ornamented their shops with flowers; and offerings of food were taken to the Temple of Vesta, where the Vestals themselves placed upon the altar some of the sacred cakes that they had made. But the most solemn of all the rites of the Vestalia was the opening of the Penetralia, into which, during these seven days, the matrons of Rome were permitted to enter freely. There, in this most sacred of places, they prayed for that which their hearts held dearest — the happiness of their homes. In deep humility, their hair down, their feet bare, the Roman mothers came to Vesta's temple, and, kneeling before her most holy treasures, entreated her blessing upon that which was most precious in their lives — the welfare of those they loved. Then, the seven holy days of the festival having passed, the doors of the Penetralia were again

closed, and the priestesses with the greatest care cleansed the sacred place from the least impurity, and threw the sweepings into the Tiber.

Although their time of special prayer was now over, the Vestals did not cease their daily petitions for the people and the government. And their prayers were thought to be of great avail, for whenever trouble or danger darkened the fortunes of Rome, it was Vesta's pure Virgins that were called upon to beseech the gods to cease their anger and to accept the atoning sacrifices offered by the people. In truth, so venerated were these priestesses, that their simple word was believed by all men, and it carried much weight when spoken in behalf of any one in difficulty. Thus, if on their way through the city they chanced to meet a criminal being led to punishment, they could cause him to be set at liberty, should righteous pity so prompt them.

If their duties were many and very strict, the Vestals had many honours also, and their estate was one of much dignity. Among other privileges, they had the right of driving through the streets of Rome, of possessing two kinds of carriages, and also of owning a stable for their

special use. A lictor always went before them, and even the consuls moved aside to let them pass, ordering their own fasces lowered as if to a higher power. Any one who injured a Vestal was punished with death, for their persons were looked upon as sacred; and one of their greatest honours was that of being buried within the city's walls, a privilege that they shared only with the emperors.

Thus Vesta's maidens were much honoured and were very powerful, but — they were also human! Even a Roman Vestal could do wrong, and when she erred her punishment was most severe. She had taken two solemn vows — one, to faithfully guard the sacred fire within the temple; the other, never to be turned aside from her holy duties by the love of man — and, either of these vows broken, she atoned her fault with great suffering. If, from lack of care, the sacred fire went out, the priestess that had it in charge was brought before the Pontifex Maximus, who governed the household of the Vestals even as the father does the family. He not only judged the wrong-doer, but he also punished her, and the careless Vestal was beaten with rods until the

blood ran. If, however, the Vestal had broken
the second of her vows, the sacred fire died out
of its own accord, for Vesta could dwell with no
impurity. At such a time the whole nation was
believed to be in danger, and a great trouble
overshadowed the people. The guilty priestess
herself met the most horrible of punishments, for
she was buried alive. Strapped to a closely
covered litter, the erring Vestal was carried to
the Campus Sceleratus, or Field of Wickedness,
that was near one of the city's gates. Following
the litter came her mourning kindred, the Ponti-
fex Maximus, and the common executioners. In
great silence the crowd separated to let the sol-
emn procession pass, not a murmur being heard
among all the throng, for Rome was stricken
dumb with grief because of the wrong-doing of
Vesta's priestess. Before a cell that had been
dug in the ground, the litter was set down, and
the High Priest, raising his hands toward heaven,
prayed that the anger of the gods might be
turned away. Then he unfastened the litter, and
led forth the unfortunate Vestal, who was given
into the hands of the executioners. She was
made to descend by a ladder into the cell, wherein

had been placed a couch, a lamb, and a little food, for it was thought sinful to starve those whose lives had been set aside for the service of the gods. The ladder was then drawn up, the cell closed, and so covered with earth that the ground was level, in order that none might remember the burial-place of the Vestal that had so heavily sinned against the goddess and the nation. But it sometimes happened that a mistake was made, and that the Vestal had not done the wrong of which she was accused. Then the goddess did not permit the faithful priestess to be unjustly condemned, but with marvellous power proved her innocence.

Thus it came to pass that when the Vestal Æmilia was in charge of the Temple, the flame on the altar was extinguished through the carelessness of a Vestal but just learning her duties. Nevertheless, the whole city was alarmed, and an evil rumour accused Æmilia of wrong-doing. Then this priestess, whose hands were clean, whose heart was pure, stood forth beside the altar of her goddess, in the presence of the pontiffs and of the other Virgins. Stretching out her arms in supplication, she besought Vesta to

protect her, and to prove her not unworthy her holy trust. "O Vesta!" she prayed, "if in all thy ways I have served thee faithfully, assist thy priestess, I beseech thee!" And having said these words, she tore off a piece of her garment of white linen, and threw it upon the altar. Then from the cold ashes came a flame of dazzling brightness that shone through the linen and consumed it; and, untouched by human hand, the fire burned again in token that Vesta herself declared her maiden innocent.

A still more wonderful sign of the goddess's favour was given to Tuccia, another Vestal whose fair fame was blackened by false accusation. Having called upon Vesta to guide and to protect her, this priestess gained the consent of the pontiffs to prove her innocence in whatsoever way she would. Followed by an anxious throng, she went to the banks of the Tiber, and there, bending over the swiftly flowing river, she filled an empty sieve with water. And, marvel of marvels, no single drop fell through! Then, holding the miraculous sieve high above her head, Tuccia led the rejoicing people back to the Temple of Vesta, where she poured out the water at

the feet of the pontiffs. And after this, they say, he who had spoken evil against her could never be found, either dead or alive.

But the Pontifex Maximus did not always have to mete out severe punishment to the Vestals; there were times when a stern reproof was sufficient. For after all, Vesta's maidens were much like other women, who, if they are fair, would be made more fair by adornment, and who, if they be not fair at all, would have adornment make them seem so. And it was this very feminine ambition that brought trouble to the Vestal Postumia. Whether she was fair or not the old writers do not tell us, but they do say that because of the gayety of her dress, and the lightness of her manner, she was brought before the pontiffs. As nothing more serious could be proved against her, she was allowed to go unpunished, but, by the advice of all the pontiffs, the Pontifex Maximus severely reproved her. At the end of a long talk, he ordered her to refrain from indiscreet mirth, and in her dress to pay more attention to the holiness of her office than to the fashion of the day.

So before they reached the honours of the Vestalis Maxima, the young Vestals had much to

learn. However, although some were faulty, and some were foolish, the priestesses of Vesta proved themselves worthy, for the most part, of the trust of the Roman people, and even in times of greatest danger did not fail in their sacred duty to the nation.

Thus when the Romans met their first great defeat — when the dreaded Gauls entered their city as conquerors — it was the Vestal Virgins that saved the nation's holy treasures from falling into the unclean hands of the barbarians. In this they were aided by the Flamen Quirinalis, or chief priest of Quirinus, a god of War, and none other, so some say, than Romulus himself. For, according to the legend, Romulus went from earth in a fiery chariot, and was taken by his father, Mars, to dwell forever among the gods. Now while the people were rushing hither and thither in wild distress, and were gathering their belongings for flight from the doomed city, the Vestals and this Flamen were consulting together as to the best manner of saving the sacred things of Rome. Without a thought for their own safety, they sought only to protect the holy objects, and at last they decided to put some of the sacred

things in a certain dolium, or large earthen jar, which was in the cellar of the chapel next to the house of the Flamen. For in many cellars these big jars were sunk halfway into the ground, and were used as a place of storage. If then such a jar were to be completely buried, any treasure within it would surely be safe from the plundering hands of the enemy. Accordingly, some of the sacred things were buried in this dolium, and hence the place round about was called Doliola, and became hallowed from that day. When this had been accomplished, the Vestals, carrying the fire and the most precious of the holy objects, made all haste to leave Rome. Reaching the Tiber, they crossed the Pons Sublicius, and began to mount the Janiculum Hill. Hundreds of men and women were hurrying along this same road, and among the anxious, frightened throng was Lucius Albinius, a rich Plebeian. He, his wife, and young children were being conveyed in a wagon, and, with the rest of the citizens, were seeking a refuge from the expected onslaught of Rome's fierce enemy. But when Albinius saw the holy Vestals toiling up the hill, the sacred things held closely in their arms, he would not

suffer them to proceed. For he thought it not
fit that the guardians of the nation's welfare should
go thus laden, while he and his family rode at ease.
Descending, he ordered his wife and children to
alight also, and offered their places to the weary
priestesses, who gladly availed themselves of his
kindness. Nor did he leave them until they and
their sacred burdens were conducted to a place of
safety. And for this act of reverent self-denial,
Albinius gained the thanks, not only of the
Vestals, but of all the people; and in after-times,
when the story of the coming of the Gauls was
told to other generations, this Plebeian was still
spoken of as among the heroes of that day.

When the Vestals returned to Rome, a sad
sight met their eyes, for the Temple, the Atrium,
and the Regia were all destroyed. The sacred
things were without a sanctuary, the priestesses
without a home. However, it was not long before
each of these buildings was rebuilt, for the hearts
of the Romans were not quieted until Vesta's pure
fire was again alight upon the nation's hearth.

In all their long history, the Vestals were only
once known to desert their goddess. This was
when a great fire swept over the Forum, and,

among other buildings, laid the Atrium and the Temple of Vesta in ashes. As the flames attacked the buildings nearest them, the Vestals, weeping, rending their. hair, and standing transfixed in very terror, were as those distraught; then, as the fire reached the Atrium itself, they rushed wildly out, fleeing for their lives. The High Priest, Metellus, who was with them at the time, called upon them to stop, or at least to give him the sacred contents of the Penetralia, which none save their virgin hands were permitted to touch. But unheeding his entreaties, the terrified Vestals made only greater haste. And in despair Metellus, already surrounded by the flames, rushed into the Penetralia, crying: —

"Forgive me, Vesta! for I am about to lay hold on that which is forbidden to man's touch. If this be a crime, then full upon me fall the penalty of my sin; and though it cost my life, let Rome be redeemed!"

Whereupon he seized the jar in which were the Palladium and the other sacred things, and, staggering through the raging fire, he escaped from the falling building. When the anxious crowd came near him, he saw them not, for his

sight was lost, and although one of his arms still held the holy jar, the other was forever gone. The pledges of the gods were saved, but at a costly sacrifice indeed! In their desire to pay this hero the highest honours, the people of Rome granted him a privilege permitted to no one since the foundation of the city, for whenever he attended the meetings of the Senate, Metellus was driven to the Curia in a chariot. And all men extolled his devotion to the gods, and hailed him as the rescuer of Rome's greatest treasure.

This fire, although it greatly injured the Temple and the Atrium, spared the Regia, which, however, was entirely destroyed in another fire that raged in the Forum a few years later. But in the midst of these unholy flames of destruction, the sacred flame upon Vesta's altar burned unwaveringly; for the holy place was saved by the devoted efforts of thirteen slaves. During the day and night that this awful fire lasted, these brave men did not cease their endeavours to protect the Temple; and, as a reward for their noble act, the public at once purchased them, and gave them their freedom.

Although rebuilt, it was not long before the Regia again suffered from the flames, but this time it escaped complete ruin, for the chapel of Mars and the laurel trees in front of the doors were untouched. The round Temple of Vesta was also unharmed; and about its bronze roof the row of dragons' heads, which, according to a Roman custom, had been placed there as a protection from evil, appeared to be still watching out for the safety of the goddess and her priestesses.

The Vestals' lives were spent, for the most part, in performing daily rites in the Temple and the Atrium, and in attending other solemn ceremonies, yet their wonderful influence was felt far and near, for their mere presence made even wrong seem right, and whatever they approved no man dared gainsay. Thus a certain ambitious consul, Claudius Pulcher, claimed the right to ride in triumph through the streets of Rome, and, despite the refusal of the honour by the Senate on the ground that his victory was unworthy such high reward, he did not abandon his design. For still persisting, although a tribune tried to drag him from his chariot, he per-

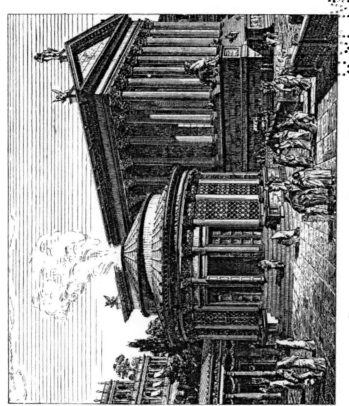

RESTORATION OF THE TEMPLE OF VESTA.

suaded his sister, Claudia, one of the Vestal Virgins, to stand beside him as he drove, and, guarded by her revered presence, rode in safety to the Capitol.

In truth, all concerning the worship of Vesta was so shielded from anything impure or unholy, and men held her temple in such reverence, that hardly did it seem possible for evil to approach the sacred spot. But during the days when Marius was Rome's cruel master, many forgot the honour due the gods, and ceased to respect even this holiest of shrines. And here a horrible crime was done, for Scævola, the Pontifex Maximus himself, was murdered at the very feet of Vesta's image. Ruffians, hired by Marius to rid him of his enemies, attacked the High Priest in the Forum, and dealt him grievous blows. Managing to escape from his assassins, the wounded Scævola ran toward the Temple of Vesta, where he threw himself down before the shrine of the goddess. Here his murderers fell upon him with such fury, that the statue of Vesta was sprinkled with the blood of her High Priest.

It was also during the time of Marius that Clodius, a tribune of bad repute, ventured into

the Regia while solemn rites, forbidden to men, were being performed in honour of the Bona Dea, or of Maia, the goddess of Spring, who guards all newly grown things. They say that once Hercules, much athirst, would have drunk from a certain fountain sacred to the Bona Dea, but that the goddess forbade him to approach. Upon this a quarrel arose between them, and from that time women were not allowed to join in the festival of Hercules, nor men to be present at the rites of the Bona Dea. The chief festival of this goddess took place at night, and the Vestal Virgins themselves conducted the sacred ceremonies. Clodius, however, had respect neither for the gods nor for man, and donning a woman's attire, he easily gained entrance to the Regia. But his voice betrayed him, and he was soon discovered. The offended Vestals and the indignant matrons turned him out with loud cries; and he was accused before the Senate of having insulted the gods of Rome. But, so corrupt were the men of that day, that he was permitted to go unpunished, and he lived to commit many other and even greater crimes.

Those were indeed times of unhindered wick-

edness when crime, quickly following wrong, brought on the day on which Julius Cæsar, the founder of Rome's empire, was treacherously murdered. His envious enemies, their dread plot arranged, waited only his next coming to the Senate to accomplish their evil work. In the meantime, both heaven and earth seemed to give warning of the approach of danger; for lightning was seen, and thunder heard in unclouded skies, and the sacrifices offered by the dictator himself were unfavourable.

The augurs, who read signs of fate in the actions of birds, announced that now the sacred fowls would neither fly nor eat; men of flames were seen fighting in the heavens; and in the night before the death of Cæsar, his wife, Calpurnia, had a most troubled dream. Now among his other honours Cæsar was Pontifex Maximus, and therefore had his dwelling in the Regia, to which the Senate, that further dignity might be given to the house of the dictator, had just added a new pointed roof, and a portico like that of a temple. As she slept, Calpurnia, in a vision, saw this roof fall in, while before her lay her husband, stricken with many wounds.

Whereupon she awoke, and cried aloud in fright, for the windows and doors of the Regia were opening of their own accord with a great noise.

Moreover, in the midst of this disturbance was heard another and more dreadful sound — a loud clashing of the sacred spears in the chapel of Mars, where those holy weapons were reverently guarded. For in the very early times, when there were no images of the gods, men had bowed down instead before their symbols, and these sharp-pointed spears, the emblems of the god of War, had hung in this chapel, so men say, ever since the days of good King Numa. Whenever they moved, danger threatened, and on that direful night they clashed so loudly that all within the Regia heard and trembled. All save Cæsar, who, in dreams, thought that he rode on clouds until he reached the highest heavens and touched the hand of great Jupiter himself. So when the morning was come, unheeding these evil omens, he prepared to go forth to the Senate, where he was expected, alas! not by the senators, but by his cowardly assassins. Then Calpurnia, mindful of all the warning wonders of the night, entreated

him with tears to remain at home. At this, however, the great Conqueror only smiled, and said: —

"'The things that threatened me ne'er looked but on my back; when they shall see the face of Cæsar, they are vanished. Danger knows full well that Cæsar is more dangerous than he.'"

And with these brave words he went forth — never to return. For on that day was foully murdered the greatest man Rome ever called her son.

To each citizen of Rome, Julius Cæsar left a sum of money, and to the public he gave all his pleasure gardens on the banks of the Tiber. This was found stated in his will, obtained from the Vestal Virgins, who not only had charge of the wills of important men, but kept in their care many other deeds of value.

In the reign of Augustus the Regia was burned for the third time, but it was soon rebuilt in solid marble, and was ornamented with many statues. Under this same emperor fire again attacked the Temple and the Atrium, and the waters of a great flood damaged them. Augustus, however, restored the Temple and beautified it with many spoils from foreign lands, and he

175

also made a gift of the Regia to the Vestals. Although Pontifex Maximus, as were all the emperors, he preferred to live in his new palace on the Palatine Hill; and from his day the Regia ceased to be the abode of the High Priest, the other emperors also dwelling elsewhere, in houses of their own.

Nero's fire did much harm to each of these three buildings, — the Temple, the Atrium, and the Regia, — but they were all restored by that wicked emperor. Then in the reign of the Emperor Commodus, these buildings suffered for the last time from fire. The priestesses fled for safety to the Palatine Hill, carrying the sacred things with them. In their haste the Palladium became uncovered, and thus, for the first time since the day when Æneas brought the heaven-sent statue to Italy, it was seen by other than the chosen guardians of Rome's treasures. The Regia and the Atrium were restored by the Emperor Severus, whose wife, Julia Domma, re-built the Temple.

During the Empire, the honours and privileges of the Vestals became greater, for more money was given them, some of the best seats at the

Ruin of the Temple of Vesta.

Circus and the theatre were reserved for them, and their power in affairs of state was yearly increased. Thus in the large court of the Atrium, where were many statues erected in memory of famous priestesses, there were also some of Vestals that had aided men to high positions in the government; this honour had been gratefully paid them by those that had received their timely assistance. For the Vestals often used their influence to help those they considered worthy, and fortunate indeed was he that could boast their good-will. So it happened that several of the Atrium statues, of which there were over a hundred, were to the same Vestal. Strangely enough, among all these images of priestesses there was one of a man, for the Vestals, in their turn, gratefully erected a statue to Vettius Agorius Prætextatus, a magistrate that had used all his power in a stanch defence of the ancient gods against the ever growing strength of Christianity.

But the Christians were not the only ones that strove to stay the rites of Vesta, for under the mad and wicked Emperor Heliogabalus, the gentle goddess suffered great insult. When this ruler came into power, he decreed that all the gods in

Rome were to be but as the servants of a certain
Syrian god of the sun, Heliogabalus, whose name
he bore, and whose devoted worshipper he was.
Moreover, as all fire was sacred to this deity, the
order went forth that the flame on Vesta's altar
be extinguished. But as the Vestals refused to
obey the Emperor's command, he became violently
angry, and, forcing his way into the Penetralia,
stole the jar containing, as he believed, the holy
pledges of the nation. The jar, however, was
found to be empty, and in helpless rage, he dashed
it in pieces to the ground. After many attempts
the Emperor at last succeeded in carrying off the
Palladium, which he fastened with chains of gold
and placed in the temple he had built to the Syr-
ian god. This caused vast indignation throughout
the city, and later the sacred statue was restored
to the care of the Vestal Virgins.

Notwithstanding the opposition of Heliogaba-
lus, the faithful priestesses continued their sacred
rites; but even after the death of that emperor,
they were not left in peace. The strength of
Christianity became ever greater and greater,
until they could no longer battle against it. An
inscription on one of the pedestals of the statues

in the Atrium would seem to show that the power of this religion was felt within the very Temple itself, and that an honoured Vestalis Maxima left the service of Vesta to join the new faith. For beneath the statue were placed words of high praise, but the name of the priestess was hammered out, as a sign perhaps that although virtue should always be remembered, the Vestal was to be forgotten and as if she had never been. The doors of the Temple of Vesta were the last closed by the Emperor Theodosius, who also banished the Vestals from the Atrium. Before they left the sacred place, the priestesses, in deep sorrow, watched the holy flame die out upon Vesta's altar, the hearth of the Roman people, where it had burned for eleven centuries. And with their own hands they destroyed the Penetralia ; but what was done with the sacred things no man can tell.

In later times much of the marble of the Temple, the Atrium, and the Regia was taken away for the building of the great church of St. Peter, and to-day only their sad ruins are to be seen. Of the Temple there is little besides the foundation, and of the Regia there are only a few fragments of its walls, but enough remains of the

Atrium to show at least the plan of the Vestals' home. One can see that the building was not only large, but elegant, and that the private rooms of the priestesses, as well as the apartments of state, were lined with marble. There were also bath-rooms, a cistern to hold the water brought from the sacred spring, rooms for servants, a kitchen, and a mill. This mill was large, and was turned by a slave, but was not the one used by the Vestals for the holy flour, which was always ground in a simple hand-mill by the priestesses themselves. As the Atrium was built into the side of the Palatine Hill, little sun reached it, and it was very damp; for this reason it was heated by hot-air furnaces, many of the pipes of which are still to be seen. But, unlike other Roman houses of the time of the Emperor Severus, from whose reign these ruins date, no pipes for water are found in the Atrium. For the rites of Vesta forbade the use of any save running water, such as that of rivers or of springs, and to their last days that used by the Vestals was carried to the Temple and the Atrium even as in the early times.

And through all those centuries, Vesta's temple kept the shape of the round hut of the market-

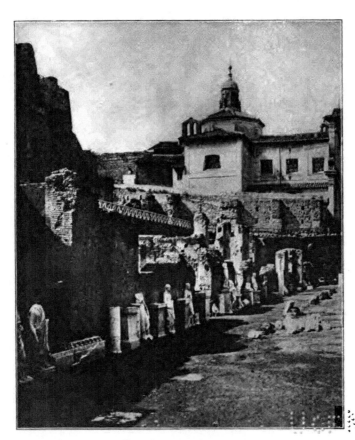

Ruin of the Atrium.

place in which the public fire was ever burning; and her worship was always the same as directed by Numa, who first taught the Romans the sacredness of the home. For surely the glowing hearth is the centre of the home — without fire, how can man cook? and without cooking, how can he live? Thus the hearth must be alight, the house clean, the stores well kept, and the housekeepers good. The very name of the goddess means to "inhabit" or to "dwell in"; and the "vestibule" was the entrance to the place — either the Temple or the home — where Vesta's fire was burning. The Penetralia of the Temple was but a symbol of the store-room of the home, and in all the rites of this gentle goddess, three great lessons were continually taught the Roman people — those of simplicity, of cleanliness, and of purity.

There were times in Rome's history when these lessons were of little profit, and during the last days of the Empire, they were not heard at all; but looking back beyond those dark years, the meaning of Vesta's worship may still be seen. Brightly and clearly burned her fire, showing the sacredness of all that makes, in hearts and in life, the light and the warmth of home.

V

THE STORY OF THE TEMPLE OF CASTOR AND POLLUX

ONE evening, although the twilight was fast darkening into night, the Forum of Rome was full of people. Men were talking together in anxious groups, magistrates were holding long consultations; for the army had gone out to battle against their exiled king, Tarquin the Proud, and that day there had been a hard fight at Lake Regillus, not many leagues from Rome. Many were the heavy hearts weighed down with fear as the night drew on, and still no tidings of either weal or woe; many were the watchful eyes strained far into the gathering shadows for the messenger hourly expected from the Roman hosts.

Now close by the Temple of Vesta, there was a spring that belonged, it is said, to the nymph Juturna; and so pure and clear were these

waters that they were believed to bring healing to mankind. Some citizens, in their restless wanderings, now came near this fountain of Juturna, and most surprising was the sight that met their eyes. Before them stood two noble warriors, whose steeds, all flecked with foam, were drinking from the sacred spring. The armour of these strangers gleamed brightly in the dusk, although they had the air of those that had not only ridden far and fast, but that had fought long and hard. In each right hand was a mighty spear, and upon each egg-shaped helmet shone a star! In awed tones the news of their arrival passed from man to man, until all that were in the Forum had gathered about the warriors, who, unmindful of the multitude, continued to refresh themselves and their pure white chargers with the sparkling waters. However, when every one had drawn near, the splendid strangers stood up side by side, and, as with a single voice, spoke to the spellbound people, saying,

" Hail, men of Rome! Let your hearts be uplifted! From Lake Regillus do we come, and would have you know that Tarquin is vanquished, and that Rome's standards are planted in his very

183

camp. Right valiant has been the fight, for the cause of Rome has this day been defended by the favour of the gods."

Having thus spoken, the glistening knights remounted their noble steeds, quieting them by calling their names in gentle tones — "Ho, Kanthus!" "Now then, good Cyllarus!" — and the voice of these warriors was like the sound of deep, sweet music. Then, with a gesture of farewell, they gave rein to their horses, rounded the road by the Temple of Vesta, and — were gone!

No trace of the mysterious riders could be found, and a wonderment, almost a fear, seized upon the people in the very midst of their rejoicings. Some murmured that the warriors had been but a vision of overwearied brains; but the more devout among them declared that these had been no earthly visitors, and that none less than Castor and Pollux, sons of Jupiter, had brought this good news to the Roman people. At this, still greater gladness reigned, and the Romans continued their rejoicings, recalling to one another the many marvellous deeds of these Great Brothers. And wonderful, indeed, were the tales they told — how Jupiter, who when on earth took

many forms, had once become a swan; how the Twin Brothers had been born from a great egg; and how Leda, their fair mother, had tended them. It was because of their strange birth, so they further said, that the helmets of the Brothers were egg-shaped, and because of their heavenly origin that stars shone brightly upon their heads. Great in war were Castor and Pollux, but, above all else, great were they in their love the one for the other. Together they gave their special favour to manly games of skill and strength, and to them all knights made vows, and all soldiers offered sacrifices.

Such were Rome's champions at Lake Regillus, for with the next morning's light there came a messenger in haste from the Roman camp, bearing a strange report. This message, opened with intense interest, was wrapped, as a sign of triumph, in leaves of laurel, as was the custom of victorious generals when informing the Senate of an important conquest. And in this letter from the dictator Postumius, were words proving that, in very truth, the sons of Jupiter had fought for Rome. For, so wrote Postumius, at a moment when the Romans were hard pressed and

their courage grew faint, two warriors on pure white steeds had suddenly appeared among their foremost ranks. Before them, Tarquin's army had fallen back in great confusion, and soon the victory was with the knights of Rome. Upon this, the marvellous defenders of the new Republic had disappeared. Then, so ended the letter, all knew that the contest had been gained by the favour of the gods, not by the strength of man; and immediately upon the battle-field, a temple had been vowed to the great Twin Brothers, in gratitude for their valiant aid.

So runs the old story, and, in fact, a few years later a temple to Castor and Pollux was built in the Forum, just on the spot where, men say, the heavenly visitors announced the good news to the people; and the son of Postumius dedicated it before all the citizens of Rome. This temple stood upon a high foundation, and was approached by flights of steps; and within it was a treasury where, as in many other temples, the people might leave for safe-keeping any of their gold, silver, or other articles of value. It became the custom to hang in the Temple of Castor and Pollux, certain tablets on which were engraved

treaties with conquered tribes, and decrees of various kinds; here were also kept the standard weights of Rome, by which all other weights were tested. Statues of the great Twin Brothers were later placed in the Temple, ever carefully kept in perfect order and repair.

Indeed, the Romans had good cause to honour Castor and Pollux, for the old writers tell us that again these valiant sons of Jupiter showed their favour to the Romans by bringing glad tidings to Rome. When the heavenly Brothers appeared for the second time, the nation was at war with King Perseus of Macedon, and the Roman army was commanded by the consul Paullus Æmilius. It happened that as a certain man, named Vatinius, was returning to Rome one night, he saw two horsemen on pure white steeds, coming quickly along the road. Their armour shone through the darkness with dazzling brightness, and their forms were of a beauty far exceeding that of man. As they neared, Vatinius moved aside to let them pass, whereupon they called out to him to halt.

"Stay, good Vatinius!" cried they. "We bear joyful news for Rome! Go thou to the Senate

and say that this day a great victory hath been won in Macedon."

With these words they passed on, their horses, fleet as the wind, bearing them swiftly out of sight.

All amazed, but feeling sure that these glorious knights were none other than Rome's ancient champions, Castor and Pollux, Vatinius made haste to seek out the magistrates, and to tell them what had befallen him. But the senators doubted him, and cast him into prison, because, as they thought, he would play a trick upon the Roman people at a moment when the whole nation was troubled concerning the fate of so many of their bravest and noblest men.

But in due season news reached Rome from Paullus Æmilius himself, and his report stated that a great conquest had been gained by his army on the very day that the Twin Brothers had appeared upon the highway to Vatinius. So great was this victory, that not only was the long war ended, but King Perseus himself was taken prisoner. Then, by order of the Senate, Vatinius was released from his chains, and lands were given him in atonement for his unjust sufferings.

Paullus Æmilius had sent this good news to the Senate by three noble Romans, one of whom was named Metellus. Many of this man's family were warriors of renown, but there was one among them whose record was unworthy that of the rest. This was his nephew, Metellus Dalmaticus, whose last name was gained by the war waged by him against the people of Dalmatia, a nation on the coast of the Adriatic Sea. Although the Dalmatians had given no offence, Metellus went out against them in order that he might be seen in Rome with all the glory of a victorious general. He triumphed without opposition, but without merit, and without honour. Much of his booty was used in the rebuilding of the Temple of Castor and Pollux; Metellus hoping perhaps by this use of his spoils to right himself with the Roman people, who held him in no high esteem. Other statues and many paintings were now added to the Temple, which became one of the most beautiful in Rome.

About this time there was much trouble in the city concerning the money-lenders, who, unheedful of the laws, loaned their money at too high rates, thereby unjustly oppressing those that had

189

need to borrow. These wrongs, the magistrate, Asellio, determined should cease, and to this end he decreed that all disputes between debtors and money-lenders should be judged in open court. Upon this the money-lenders became angry, and, plotting against Asellio's life, many of them mingled one day with the crowd worshipping in the Temple of Castor and Pollux, while Asellio was offering a sacrifice to the great Twin Brothers. The place was still, as with veiled heads the people stood reverently before the altar, where Asellio, clothed in gilded robes, held the libation bowl within his hands. Suddenly, a stone was thrown at him with great force, and turning, he saw, beyond the bowed heads of the worshippers, many of his enemies, their evil looks threatening him with death. Trembling with fear, and dropping the sacred bowl, Asellio ran out to seek refuge at Vesta's shrine, — but the assassins were there before him! Then, in desperation, he fled into a tavern near by, and there his pursuers followed and slew him.

Strangely enough, this evil deed happened in the Forum of Rome in broad daylight, and while this magistrate, surrounded by many persons, was

sacrificing in a temple. And, still more strange, although the Senate offered high reward, no trace of the murderers could be found. For so powerful were these money-lenders that not only was their guilt covered up, but their business was still carried on with as little justice as before.

Yet greater injustice took place in the business affairs of the Temple itself, which was repaired and cared for by men to whom the city paid a certain sum. Now at the time when Gaius Verres was the city magistrate in charge of the public buildings of Rome, the Temple of Castor and Pollux was kept in repair by one Lucius Rabonius. Acting for a youth not yet of age, one whose father had carefully kept the Temple for many years, Rabonius strove to do his duty honestly and well. This, however, was far from pleasing to Verres, who, cunningly keeping his coffers filled from the public funds, hoped to gain large sums from the work on such an important temple. But all was in order, all according to agreement, and Verres sighed with discontent as he gazed from the beautiful ceiling to the many statues, and from these to the rich paintings that adorned the

191

sacred place. Just then there came to him a friend, even more cunning than himself.

"Wouldst fill thy pockets, Verres?" whispered he. "Cause the columns of this too perfect temple to be tried by a plumb-line."

"And wherefore?" queried the magistrate, with puzzled interest. "What meanest thou by a plumb-line?"

"'Tis a line bearing a heavy weight, by which all upright things may be tested, O Verres," spake his evil counsellor. "Know that few columns stand exactly straight. Try these by a plumb-line, wise magistrate, and, I beg thee, forget not thy friend!"

The grasping Verres, accepting this advice, forced Rabonius to tear down the columns, and to set them up again. And the money used for this unneeded work was that belonging to the helpless youth, a large part of whose fortune thus slipped into Verres's ever yawning pockets.

Many were the scenes of riot that took place both within and without the Temple of Castor and Pollux, for the Senate at times held meetings there, and the lofty steps of the building often served as rostra, from which addresses were made to excited assemblies of the people.

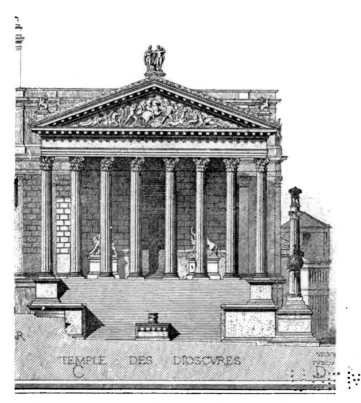

RESTORATION OF THE TEMPLE OF CASTOR AND POLLUX.

It was upon these steps that Julius Cæsar stood to address the people concerning a new law. He was then consul, and to gain the good-will of the Romans, he proposed that certain lands belonging to the State be divided among some of the poorer citizens. As the delighted crowds cheered him loudly, Marcus Bibulus, the consul of the opposite party, entered the Forum and approached the Temple of Castor and Pollux. The throng willingly separated to let him pass, for they hoped that he also brought good news; but when Bibulus had mounted the steps, he denounced Cæsar's methods, and cried out against the new law that had found such favour with the people. Whereupon he was thrown down, and forced to leave the Forum, barely escaping with his life from the angered multitude. Then, keeping safely within his own house, Bibulus tried still further to hinder the passing of the law by announcing day after day that he had consulted the augurs, and that, concerning such an act of the Senate, there were evil omens only. His efforts, however, were all in vain. Cæsar swept everything before him, and none listened to the piping of so small a voice as that of Bibulus. All eyes were upon Cæsar; he

was the hero of the day. Even in the feasts and games which, for their own advancement, the consuls together gave the people, all the praise was Cæsar's. Although Bibulus shared the expenses equally with Cæsar, he received no thanks, and for this reason he was wont to say that Fate had dealt with him as with Pollux. For although a temple had been built in honour of both Brothers, it was generally spoken of as the Temple of Castor only. "And so," said Bibulus, "although half the money spent is mine, the glory is Cæsar's alone."

During the reign of the Emperor Augustus, the Temple of Castor and Pollux was rebuilt by Tiberius, the adopted son of the Emperor. When the work was finished, and the Temple stood white and glistening in all its marble magnificence, it was dedicated to the great Twin Brothers, in the name of Tiberius and of his own brother Drusus. For although Drusus, a good man and a brave warrior, had been killed while at war against the Germans, he still lived in the hearts of the Roman people, who rejoiced in the thought that the love of Castor for Pollux was reflected in the affection of Tiberius for Drusus.

A curious change was made in this Temple by

the mad Emperor Caligula, whose lofty pride caused him to feel greater than the very gods themselves. His mad conceit knew no bounds, and when he built his palace on the Palatine Hill, he did not hesitate to use the Temple of Castor and Pollux as its vestibule. Now the vestibule was the court before a rich Roman's house, and in it stood servants guarding against thieves, and obeying the wishes of those desiring to visit their master. Caligula's wild fancy caused him to announce that this beautiful Temple should be the vestibule of his house, and that the Great Brothers should serve as the lowly guardians of his doors. And further, as if to force the people to acknowledge his more than human greatness, this profane and wicked man often sat between the statues of the heavenly Brothers, that with them he might be adored by those that worshipped. However, after the death of Caligula, the next emperor, Claudius, commanded that the Temple be restored as a place of worship, and that the holy rites thereof be renewed with all their former solemnity.

Three beautiful columns still stand upon the high foundations of the Temple of Castor and

Pollux. They are part of the building dedicated by the imperial brothers, Tiberius and Drusus, to the sons of Jupiter, Castor and Pollux; and these graceful pillars are pointed out to-day as among the most beautiful of Roman ruins.

During all Rome's history, until the worship of the ancient gods was ended, there took place every year a certain procession, watched by the people with never failing delight. It occurred on the anniversary of the battle of Lake Regillus, on which day the Roman knights rode forth to do honour to the great Twin Brothers. All the way from the Temple of Mars, just beyond the city's walls, to the Temple of Jupiter, on the Capitoline Hill, the road was lined with happy throngs, eagerly waiting for the first glimpse of the glittering hosts. And at last they came, five thousand strong, the best and bravest of Rome's warrior sons. Entering the city by that gate through which, so many years ago, the victorious Postumius had come in triumph, they proceeded, mounted upon shining steeds, in the order of their rank. Their robes were of purple, and they bore all the ornaments gained as rewards of valour upon the field of battle; but on their heads were only chaplets of

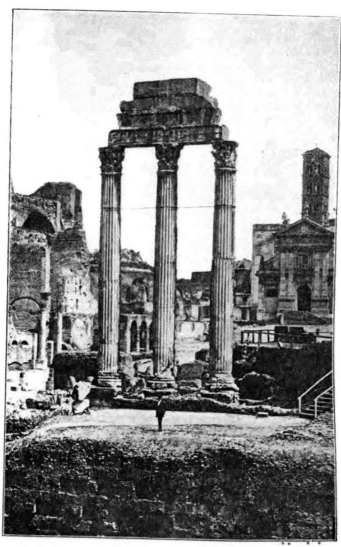

RUIN OF THE TEMPLE OF CASTOR AND POLLUX.

olive leaves, for on this day they celebrated peace, not war. Well might the hearts of the Romans glow with pride as they gazed upon so many valiant men, for splendid indeed were these knights as they passed along — armour gleaming, colours waving, standards glistening, and trumpets blowing. Within the Temple of Castor and Pollux a magnificent sacrifice was offered to Rome's heavenly champions, and then the brilliant train moved onward to great Jupiter's temple on the hill above.

Since the first troublous days of the Republic, the citizens of Rome again and again had waited in the Forum for tidings from the army, and again and again news had come to them of victory, but never had greater anxiety been replaced by greater gladness than when Castor and Pollux brought the word of triumph from Lake Regillus. For to the ears of the oppressed people to whom it came, it sounded both as the knell of the tyranny of kings, and as the joyous peal announcing the freedom of Rome.

VI

THE STORY OF THE TEMPLE OF CONCORD

ALONE the aged Camillus stood upon the steps of the Curia, and faced an excited multitude. Below him gathered indignant Patricians; just beyond crowded angry Plebeians. For an officer of the people had attempted to arrest him — the triumphant general, the wise statesman — even as he was sitting on his judgment-seat, and the nobles had quickly come together to protect the venerable dictator. Rome was in a state of peril, and for the fifth time the supreme power had been given to Camillus, conqueror of the Gauls, and again and again defender of his country. Now danger threatened from within Rome itself, and the very foundations of the State were shaken. The Plebeians, claiming a fairer share in the government, had demanded that one of the two consuls be chosen from among their number; the Patricians, fearing a loss of power,

had refused to grant this privilege. Then the
Plebeians, thinking that Camillus, himself a Patri-
cian, might favour their opponents, would have
cast him into prison; but the Patricians, uphold-
ing the ancient laws, stood ready to defend their
leader to the last. Strife having been thus let
loose, tumult now reigned, sweeping through the
Forum like a great wind before the outbreak of
the storm. Once more liberty and oppression
swayed in the trembling balances of Justice;
once more the fate of the nation lay in the
hands of this one man. Fearless and deter-
mined Camillus stood forth, gazing at the troubled
throng; then, lifting his eyes toward the calm
heavens, he raised his hands in supplication.
Instantly there fell a hush, as intense as the
uproar that had gone before; and in that sudden
stillness the voice of Camillus, clear and power-
ful, was heard uttering this solemn vow: —

"By all the immortal gods, I, Camillus, swear
that if peace be established among the citizens
of Rome, a temple shall be raised to the goddess
Concordia, whose worship shall be honoured of
all men. Heaven and Earth, bear witness to my
words!"

Thus spake the old dictator, and thus a new deity was added to the number of the gods — Concordia, goddess of Tranquillity, who bears in her hands the olive branch of peace and the horn of plenty.

In silence Camillus then led the senators to the Curia, where, after grave discussion, the question that had occasioned so much turmoil was peacefully decided in favour of the Plebeians. When from the Rostra Camillus announced this result, cheer after cheer rent the air, blessings and praises were heaped upon his name, and amid these wild rejoicings the people escorted the aged magistrate to his home. And soon, close to Saturn's temple, was raised the Temple of Concord that it might testify that the long and bitter strife between Patrician and Plebeian was ended.

During many years after, this long war in foreign lands occupied the people, who gained thereby much wealth, if not greater wisdom; and ambition becoming the watchword of Roman life, again the rights of the poor were cast aside, and riots and disorders disturbed the city. Yet the people did not lack friends, and more than one

brave man lost his life in defence of the poor man's cause. Thus the tribune, Tiberius Gracchus, upon proposing that certain lands be divided among the people, was killed by blows from the enraged senators; and thus his brother, Gaius, upon altering the laws in order that the poor might receive greater justice, was overcome by the nobles, and ended his life rather than fall into their hands. On the day that Gaius Gracchus died, three thousand persons were slain in the fierce fight that took place between the followers of the opposing Senate and the friends of the downtrodden people. Success was with the Senate, and, in memory of the disgraceful victory, the consul, Lucius Opimius, was commanded to rebuild the Temple of Concord. But the people were greatly angered at the thought that a temple built to Concord should remind men of the downfall of their champion, and so one night the inscription on the Temple was changed. Those that entered the Forum the next morning saw, over the entrance of the sacred building, these words, which were a reproof, indeed, from an oppressed people to an unjust government: —

"Discord raises this temple to Concord."

In these evil times Wickedness raced madly for the glittering prizes offered by Power. What Money failed to get, Fraud sought to grasp, and even among Rome's noblest citizens were found traitors to their country. Such a one was Lucius Catiline, born of an old and honoured family, but one of little wealth. Base, yet having a certain bravery; cruel, yet having a certain charm, Catiline pleased many of the people, and, counting on their support, he hoped to be made consul. As a man and as a magistrate, his record was black, yet he dared stand for this high office, so little did honesty and worth count in those last days of the Republic. And his ambition might have been satisfied had his opponent been other than the great orator Cicero, whose speeches against Catiline will be forever famous. So eloquently did Cicero denounce Catiline that the people and the Senate feared him, and in his place elected the orator himself. Thus failing to obtain the honour he desired, Catiline, gathering about him some poor and desperate nobles, headed a bold conspiracy against the State, and not only plotted to murder the consuls, but to fire and plunder the city. Cicero discovered these evil schemes, and,

in a speech full of fiery scorn, reported to the Senate, in the presence of Catiline, every detail of the plot. The senators, one and all, turned away in horror from such a wretch as Catiline, who, declared a public enemy, was forced to leave Rome. Before going, however, he met his fellow-conspirators, and, undaunted by ill-fortune, laid new plots. These fresh plans of the traitors being also revealed to Cicero, he ordered that the chief of the remaining conspirators be seized, and that they be summoned to appear at a meeting of the Senate to be held in the Temple of Concord.

Here, at break of day, when Cicero arrived with the conspirators, he found the Senate already assembled in large numbers. He entered the Temple leading by the hand the magistrate Lentulus; following came eight other prisoners, closely guarded. Such proof was shown of their guilt that not one among them could gainsay it, and the conspirators realized that their cause was hopeless. Whereupon, Lentulus, giving up his office of his own accord, took off the purple robe that was a sign of his honourable position, and put on the plain toga of the ordinary citizen. Then, until the manner of their punishment

203

should be decided, the traitors were all placed in charge of certain senators, who were ordered to keep them strictly guarded, but not to put them in chains. By this the day was far spent, yet when Cicero passed out from the Temple, he found in the Forum an immense crowd waiting to hear the result of the meeting. So, from the Temple's steps, the great orator spoke to the people, telling them of the danger that had threatened Rome, and explaining to them the actions taken by the Senate. As he left the Forum, he passed through grateful crowds that left him only when he had reached the house of a certain friend. For that night Cicero did not sleep in his own home, where the rites of the Bona Dea were being held — holy ceremonies at which no man was permitted to be present.

Now Cicero was of two minds concerning the punishment of the conspirators; he did not wish to have them die, yet he feared to let them live. So, as he sat in his friend's house, he consulted with a few tried counsellors regarding the prisoners' doom. And, even as they talked, a marvellous thing happened at the sacred ceremonies of the Bona Dea. Just as the Vestal Virgins were

ending the worship, and the fire on the altar seemed extinguished, there suddenly shot up from the dying embers a flame of exceeding brightness. All were amazed and terrified, save the priestesses of Vesta, who, turning to Terentia, the wife of Cicero, bade her go at once and seek her husband.

"Tell him," said they, "that the goddess has granted him a sign. Bid him be bold in his wisdom, and both safety and glory shall attend him."

This message from the Vestals decided Cicero; and in the meeting of the Senate, held the next day in the Temple of Concord, he used all the powers of his mighty eloquence to persuade the senators to show no mercy to the traitors. Julius Cæsar, then a young man, was bold enough to oppose him, but Cato, and other magistrates, siding with the orator, sentence of death was passed upon the conspirators. Then the triumphant Cicero, at the head of the Senate, went to the house where Lentulus was guarded, and, escorted by many of the principal citizens of Rome, brought him back to the Forum. The frightened people stood in silence while this avenging procession of

the nobles passed through the middle of the Forum, and reached the steps that led to the prison. Still in silence, the people watched Cicero as he mounted the fateful stairs and delivered Lentulus into the hands of the executioner. In the lower dungeon of the loathsome Tullianum, this high-born man was strangled to death, and there, one by one, each conspirator met the same dreadful punishment. When all was over, Cicero stood forth upon the Scalæ Gemoniæ and looked down into the Forum. Among the waiting, trembling people, he saw many that were in sympathy with Catiline, and it was to them, rather than to the multitude, that he announced that the traitors were no more. All scorn and all pride seemed united in Cicero's voice as he uttered the single word "Vixerunt!" they have lived.

As Cicero went to his home that night, the people again accompanied him, but not in respectful quiet, as on the day before. Their glad shouts now rang loudly through the air; they ran, they leaped for joy. The streets were made bright as day by many lamps and torches, placed in the doorways of the houses, in honour of this

man that had rescued Rome from such peril; and the women, standing upon the roofs, held aloft yet other lights in order that they might the better behold him. From the lowest to the highest, all gave him praise, and he was hailed by the magistrate Cato as "Father of his Country," —a title of honour given to many Romans, but first of all to Cicero.

Catiline, the chief of the conspirators, having raised an army, now gave battle to the Roman forces. He fought with the fury of despair, but when he saw that all was lost, he rushed headlong into the thickest of the fight, and fell, sword in hand. And thus ended the greatest conspiracy that ever threatened Rome.

The Temple of Concord, like that of Castor and Pollux, was rebuilt by Tiberius during the reign of Augustus. Again remembering his dead brother, Tiberius caused the name of Drusus to be placed beside his own in the Temple's new inscription. Livia, the mother of these brothers, gave a fine altar and other gifts to this Temple, and Tiberius further adorned the building with a large number of beautiful statues and paintings. Many rich and rare things were

207

kept there, and soon the Temple became famous, not only for its beauty, but also for the wealth it contained. Among its wonders were four elephants in obsidian, a stone nothing else than a thick, blackish glass made by Nature herself from sand melted in great volcanoes. This stone was much liked by the Emperor Augustus, and some of his statues were made of it.

Another marvel among the highly prized treasures of this Temple was an emerald, which, it is said, once belonged to the Grecian king, Polycrates. Now this monarch was blessed with good fortune far beyond his fellows; all that he undertook prospered; all that he wished came to pass. It so happened that Polycrates had a friend in the wise Amasis, king of Egypt, who, hearing of his unfailing success, sent a letter of warning to the too favoured Grecian. "Beware, O Polycrates, of ever smiling skies," wrote Amasis. "Beware, O royal friend, of the jealous anger of the gods! Darkness and light, joy and sorrow, bring man the surest happiness. Consider, I pray thee, and, before it be too late, deprive thyself of something dear to thy heart. Cast it from thee in such a manner that never more shall man's eyes

rest upon it. Thus shalt thou prove that thy
ambitions are but human; thus shall the weight
of sorrow keep thee safely near the earth, and
prevent thee from rising to those dangerous
heights whereon dwell the gods, and unto which
no man may attain and live."

Now when Polycrates read this letter, he per-
ceived that the words of Amasis were full of wis-
dom, and he determined to do even as his friend
had counselled. So he considered within himself
which of all his treasures he held most precious,
and at length he decided that his dearest possession
was a signet-ring, an emerald curiously carved and
set in gold finely wrought. Then Polycrates went
forth in a great ship, and when he was very far
from land, he stood upon the prow, took the ring
from off his finger, and, with a prayer to the gods,
flung it from him into the deep. This done, the
king returned to his magnificent home, and there
gave himself up to sorrow.

A few days later a fisherman, drawing in his
net, found an exceeding large fish, and, thinking
to please the king, brought it as a gift to Poly-
crates. "For," said the fisherman, "surely such
a fish is worthy only the greatness of Polycrates,".

which speech flattered the king, who forthwith invited the fisherman to sup with him.

Now as the cooks were preparing this fish, they discovered within it the signet-ring of the king, and going before him in all haste, they joyfully restored it to their royal master.

Then Polycrates, replying to the letter of Amasis, told him what had happened, and that all had been in vain. Whereupon Amasis grieved greatly over his friend, for he saw that Polycrates could not escape his fate. And, in truth, not many years passed before the Grecian king's fortune fell, for he died a miserable death at the hands of his enemies.

Over the entrance of this Temple were placed statues of Victory, and in its marble threshold, as an emblem of concord, was graven the wand of Mercury. Now Mercury, Jupiter's clever son, played one day a trick upon Apollo, and stole his fine oxen. To atone for this, the repentant Mercury gave Apollo his lyre, and in affectionate exchange received the Sun-god's wand — a wand of peace, by whose virtues the bitterest of enemies were reconciled. On his way through a wooded glen, Mercury came by chance upon two serpents,

angrily writhing in deadly fight. And, curious to test his new possession, Mercury touched the serpents with his wand, whereupon they quietly coiled themselves around it, their heads meeting lovingly together at the top. Thus he that crossed the inner threshold of the Temple of Concord, first passed over the sign that showed two enemies reconciled — over the caduceus, fit symbol of the cause in remembrance of which the sacred building had been erected.

To-day only the foundation marks the place where the beautiful Temple of Concord once stood. With the other temples, this sacred building has fallen into ruins, and, like the rest, its delicately carved marbles have been taken away or thrown into the lime-kiln. One thing, however, is still clearly to be seen, one thing has outlasted the general destruction — Mercury's wand upon the threshold still tells its story of peace, and still reminds men of the end of the bitter struggle between the Patricians and Plebeians of Rome.

VII

THE STORY OF JULIUS CÆSAR'S BASILICA AND OF HIS TEMPLE

The Story of the Basilica Julia

MANY labourers were making a great noise on the south side of the Forum, and many idlers, eagerly gathering about in groups to view the work, were delighting, as idlers will, in the sight of others' toil. The old Basilica Sempronia, the house of the great general, Scipio Africanus, and the row of booths known as the Old Shops, were all being torn down to make room for a vast Basilica, to be built by Julius Cæsar, who planned to make it worthy of his name. And as from day to day the idlers chatted with one another and watched the building grow, they looked forward with lazy pleasure to the happy hours they hoped to spend beneath its porticos.

Although the Basilica was unfinished, it was dedicated by the great dictator, not long before his death. While the work was being completed by Augustus, a fire destroyed the building, whereupon this emperor determined to rebuild it upon a yet grander scale. This he did, not only because he always enlarged and beautified whatever he rebuilt, but also because he thought thus further to honour Cæsar's memory; his plans, however, were greater than was the length of his days, and he died leaving the Basilica still unfinished. But when the building was at last completed, the Romans were not disappointed, for this splendid court of law was acknowledged to be the most magnificent gift to the people that Rome had ever received. Notwithstanding the fact that the greater part of the Basilica built by Cæsar had been destroyed, that another than he had ended the work, and that the building had been dedicated by Augustus to his own grandsons, the memory of the great dictator proved stronger than aught else, and the building was always called the Basilica Julia.

This vast edifice soon became the favourite haunt of the Romans, and at all hours of the day

its marble corridors were full of people, eagerly seeking for business, and still more eagerly seeking for pleasure. Lawyers, flower-girls, money-lenders, fine ladies, there came elbow to elbow, and when a sudden shower swept over the Forum the Basilica's broad porticos gave shelter to large numbers of the crowd.

The gay young Roman, freshly perfumed from the baths, there found amusement for his afternoons; for besides the chats he might have with his many friends, he might play in the outer porticos at games of chance. There, gold changed hands with great rapidity, and from these games men departed with smiles or frowns, according to the manner in which fickle Fortune had bestowed her favours. For the warning of reckless gamblers, wise sayings were graven in the marble of the pavement, where the play went on. And such words as these are seen there to-day: "Let him that wins, triumph; let him that loses, lament," and "Be silent and depart." Cut in the floor are the markings of a sort of checker-board, used in a game played with dice, in the throwing of which the Romans were so skilful that "Like the dice-players of the Forum," became a term of

reproach to men that would fain profit by others' losses.

The mad Emperor Caligula, who fancied that his power was more than human, not only decreed that Castor and Pollux should be the keepers of his doors, but, conceiving ideas still more profane, vauntingly called himself the brother of great Jupiter. Then, that he might seek the god with ease, this monarch caused a bridge to be built from his own palace on the Palatine Hill to Jupiter's splendid temple on the Capitoline. The bridge, however, was like none other, for this most vain "brother of a god," disdaining to build as did other men, used some of the Forum's buildings as the piers for his lofty crossing, and thus passed high in air from one hill to the other. One of these supports was formed by the Basilica Julia, and at this point Caligula used to stand, amusing himself by casting money to the throng in the Forum beneath. And if in the mad scramble that followed some were injured or even killed, his insane pleasure only grew the greater, and his wild laughter only rang the louder. After Caligula's death this bridge, together with other traces of his madness, was

taken away, for under the rule of the next Emperor, Claudius, somewhat more order reigned throughout Rome.

But the Basilica Julia was not merely a place of amusement for the people; it was also the chief law court of Rome. Within it were four tribunals, at all of which trials could be carried on at the same time without disturbing one another. This was the more wonderful because the Basilica was not divided into rooms, as are our court-houses; the great space in its centre, where judgment was given, was enclosed only by low marble screens, to which were sometimes added heavy curtains, hung between the pillars of the portico. During any famous trial the upper galleries of the Basilica held hundreds of spectators, who came to view the scene even when they could not hear what was spoken. And the sight was well worth their pains, for when an important case was to be decided, all four courts sat together in judgment.

Here Pliny, the famous advocate and scholar, once pleaded the cause of a certain lady of high rank, whose aged father, by a foolish second marriage, had cut off her inheritance. The orator, as

he rose to speak, paused for a moment and looked about him. And as he gazed upon the brilliant scene, his eye gleamed with satisfaction, for even the most ambitious could ask for nothing more. First, the building itself was one fit for the utterance of the noblest eloquence; from its walls and pillars to its wonderful floor of inlaid marble, all was grandly beautiful. Second, the assembled people were among the best citizens of Rome; from the crowds in the galleries and corridors to the one hundred and eighty judges upon their benches, all were waiting anxiously for Pliny's words. Realizing the importance of the moment and the fitness of the place, this great advocate now made one of the most noted speeches of his life, and only stopped when the man standing by the clepsydra told him that his allotted time was gone. Now the clepsydra was a hollow globe of metal or of brass, filled with water that slowly dropped away through small holes in the bottom of the vessel. By thus measuring time, the length of each lawyer's speech was determined — the number of clepsydras allowed him being greater or less according to the importance of the cause he was to plead. When documents were

read, or other interruptions occurred, the flow of the water was stopped in order that every precious drop should be saved; and this perhaps it was that led the Romans to express by the words "wasting water" all that we mean by "killing time."

For a second and yet a third time the Basilica Julia was injured by fire. It was restored, however, first by the Emperor Severus, then by the Emperor Diocletian. And many years afterward the magistrate Vettius Probianus again restored the building, and ornamented it with many statues, the bases of which are still to be seen.

The ruins of this law court are the largest in the Forum, and although there remain only parts of pillars and arches, and fragments of walls and flooring, one's fancy easily pictures the place as it was in days of yore, when in marble magnificence, it stood a stately edifice indeed.

But this Basilica tells only a small portion of Julius Cæsar's story. There are, however, in the Forum the ruins of another building from which, although smaller, there is learned much more concerning the great dictator. Yet, strange to say, Cæsar himself did not plan this building,

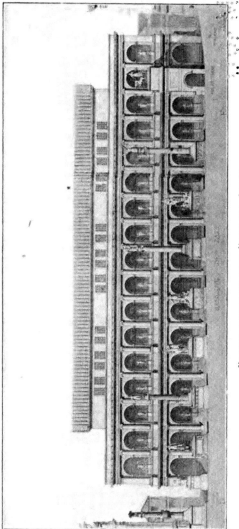

RESTORATION OF THE BASILICA JULIA.

neither had he any knowledge of it! Nevertheless, the Roman world there offered him the deepest homage, and the world to-day there pays honour to his memory. The last and the strongest proof of his fame and power is told in —

The Story of the Temple of Julius Cæsar

A low groan was heard throughout the Forum. Upon the Rostra the consul Antony knelt before Cæsar, offering him a crown and hailing him as king; around the tribunal crowded the people, watching every motion and showing their old hatred of a monarch's rule. Cæsar, hearing without seeming to listen, seeing without seeming to look, understood it all, and his hesitating gesture stiffened into an attitude of refusal, while in a firm, proud voice he said, "I am no king, I am Cæsar"; whereupon the crowd cheered loudly. Again and again did Antony offer him the crown; again and again did the great dictator push it from him, while at each refusal the people's cheers grew louder and yet more long. Thus Cæsar and the Romans tested each other's hearts.

This happened during the celebration of the

ancient festival of the Lupercalia, when all Rome
was in holiday dress for several days together, and
when sacrifices were made in the Lupercal, the
cave wherein Romulus and Remus had been
tended by their strange nurse, the wolf. As
Rome's great master, clothed in purple robes, sat
in his golden chair upon the Rostra to watch these
joyous festivities, his friend, the consul Antony,
in the presence of the multitude, offered him the
honours of a king. But Cæsar, hearing the people's
groan, felt that the time was not yet ripe; so,
knowing full well that his power already equalled
that of many kings, he let the empty honour go;
thus by his wisdom gaining the people's love, and
making his rule mightier than before.

But there was a power even stronger than that
of Cæsar. For evil Ambition plotted against him,
and cruel Jealousy killed him. Hardly a single
month had passed by before the envious daggers
of his assassins had let out his life's blood.

Then came the proof of that people's love for
Cæsar. There, upon that same Rostra whereon
he had refused to be their king, his martyred
body lay, and there, that same Antony who had
offered him the crown spoke the words of his

funeral oration. The honours that he had then refused were now vainly heaped upon him; dead he was treated as if more than king. His body, covered by a cloth of gold and purple, lay upon a couch of ivory; a countless host of men and women formed his funeral guard; and the noblest in Rome thronged to pay him the last honours. The voice of Mark Antony, his fellow-consul, his relative, and his friend, rang solemnly through the Forum. As he told of Cæsar's deeds of valour, of his love for his country, of his generosity toward his enemies, the multitudes were greatly moved. And their excitement became boundless when they heard the dictator's will, wherein he left a gift of money to each Roman citizen, and all his lands by the Tiber as a pleasure park for the people.

Then Antony sang a dirge to Cæsar, as to one more than human, even as to a god, and as he sang he raised aloft Cæsar's robe, which like a trophy had been placed at the head of the bier. And when the people saw this garment, rent by daggers' thrusts, red with the dictator's blood, they cried aloud for vengeance and joined in Antony's lament. Upon this, there was raised

above the bier a waxen image of Cæsar himself,
bearing all the horrible marks of the twenty-three
wounds given him by his assassins. By means of
some machinery this image was turned about so
that all could see, and at the grewsome sight the
multitude, mad with grief and rage, ran from the
Forum to search out the murderers.

But finding that the conspirators had secretly
left the city, the baffled people, still more angry
and excited, returned to the Forum. Reverently
lifting Cæsar's bier, they bore his body to Jupiter's
great temple on the Capitoline Hill, where they
would have had him placed at once among the
gods; but the priests forbade them entrance.
Then, carrying their mournful burden back to
the Forum, they determined that the love of his
people should give Cæsar that which Religion
had refused. So they placed his body before the
Regia, the king's house, and there they built his
funeral pyre. For this they used whatever wooden
objects could be found at hand, — benches, chairs,
tribunals, — and as the flames rose high, each cast
aside the signs of his own honours to offer them
to Cæsar, as sacrifices are offered to a god. Robes
of triumph were rent in twain and thrown upon

the pyre; the armour of Cæsar's well-tried soldiers was placed at his feet; women gave their jewels and the ornaments that hung about their children's necks; mantles of office, crowns, and other articles of value were given with unstaying hand to Cæsar, never greater than at that moment, never dearer to his people's hearts.

Nor did the Romans alone sorrow for Cæsar. Many strangers within the city came to the place where he lay, and, each after the manner of his country, mourned the noble dead. And among those that sorrowed most were large numbers of Jews, a people whose kind friend Cæsar had ever been.

All through that fateful night an armed multitude watched at the Forum and guarded the sacred ashes, which were afterward taken to the tomb of Cæsar's family. Then, upon the spot where his body had been burned, was raised a tall column of rich marble. It was placed there by the people, led by an ambitious man named Amatius, and it bore the words: "To the Father of his Country." Beside it was erected an altar, where the devoted Romans offered sacrifices and bowed the knee to Cæsar, whom they called divine.

This greatly alarmed the Senate, fearful for the authority of the State, and Cicero publicly warned the magistrates of the danger of such a wrongful worship. Whereupon the consul Antony caused Amatius to be put to death, the column to be thrown down, and the altar to be removed. A violent riot followed, and before this could be quieted many were made prisoners, and others were condemned to die. But the citizens were not content, nor was Rome at peace, until the Senate had declared that a temple in honour of Cæsar should be built on the place where had burned his funeral pyre. The altar was then replaced, and from that time all Romans ranked Julius Cæsar among the gods. And they say that in proof of this, there was shown to the people a sign in the heavens. For during the games, given by the Emperor Augustus in honour of Cæsar, his adopted father, a wonderful comet blazed in the skies for several days together. Men, awed and amazed, believed it to be the soul of Cæsar, and as a sign of his immortal power, a star was placed upon the brow of his statue.

The Temple of Julius Cæsar, built in the

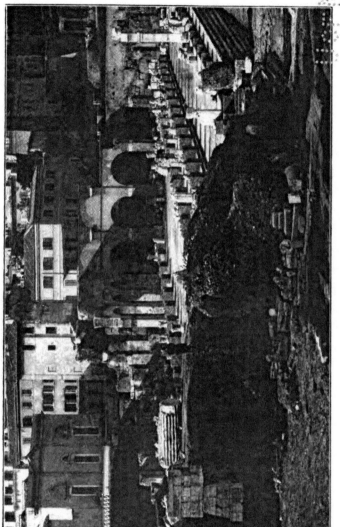

RUIN OF THE BASILICA JULIA.

lowest part of the Forum, was placed upon a very high foundation, that the waters of the overflowing Tiber might not harm it. The Emperor Augustus adorned the sacred building with spoils from Egypt, and with paintings of great worth; and he dedicated the Temple with much pomp and magnificence. The wide space in front of this Temple was used as rostra, and was called the Rostra Julia. This, Augustus also ornamented, placing thereon beaks of ships taken in the great battle of Actium. It was from the Rostra Julia that this Emperor spoke the funeral oration of his beloved sister Octavia; and it was from this same platform that Tiberius, his adopted son, addressed the people after Augustus's death.

Besides the ruins of the foundation of Julius Cæsar's temple, there are to be seen to-day the remains of the altar where he was first worshipped. This, perhaps, more than aught else that reminds men of the famous Conqueror, tells the story of his greatness. For it was raised to a man so honoured by the bitterest of his enemies, so loved by the most envious of his friends, that at the end they united to bestow upon him the most exalted meed of worship.

VIII

A BAND of weary, wounded men were dragging themselves slowly along the highroad toward Rome. In the distance the city could be faintly seen, but so worn were these wayfarers that they showed no joy at the nearness of their journey's end. Their leader alone was hopeful, and spoke words of cheer to his downhearted men.

"Courage, brothers!" cried he. "See, Rome lies just beyond. Bethink ye of the kindness of Porsenna to these people in their time of famine. Surely, Etruscans will be well received within these walls!"

"Nay," replied a voice in the rear, "bethink *thee* of Cocles on the bridge! Bethink thee, too, of Mucius who would have killed our king! Though the Romans be brave as lions, they have hearts of stone!"

But the leader of these men — all that remained of the army sent by King Porsenna against the tribe of the Aricians — listened not to such dark sayings, but with brave words continued to encourage the tired soldiers until at last they stood before the gates of Rome.

Weary unto death, hopeless, forlorn, their clothing rent, their armour gone, these soldiers of the Etruscan king came as suppliants to their ancient enemy. And, as the surprised people gathered about them, they told the tale of their misfortunes. Thus the Romans learned that the Etruscans had been defeated by the Aricians, that the king's brave young son had been killed, and that of all Porsenna's army there remained only the few men that now besought their pity and their help. And this was freely given, for the Romans proved themselves as firm friends as they had been bitter enemies. The wounded soldiers were gently cared for, their hurts healed, their clothes renewed. And thus it happened that, having formed a great affection for the Roman people, many of these Etruscans remained in the city wherein they had received so much kindness, and there built themselves

homes. For this purpose land was given them, and the place where they dwelt was thereafter known as the Vicus Tuscus, or the Etruscan Street. This ancient roadway passes between the Basilica Julia and the Temple of Castor and Pollux, and although shorter and less important than a road called "Via," the Vicus Tuscus was among the most famous streets of Rome.

In the Vicus Tuscus, near the Basilica Julia, there stood a bronze statue of Vertumnus, god of Gardens, of Fruits, and of Flowers, who bears a pruning-knife within his hand, and to whom were offered garlands of buds, and the early ripenings of the orchard. Now Vertumnus, also the god of Change, took upon him many shapes, and because he loved Pomona, a fair goddess who shared with him the care of fruits and flowers, he appeared in various forms, hoping to catch her fickle fancy. To-day he was the hardy reaper, returning from the field, his arms laden with ripe ears of corn; to-morrow he might be a gay soldier, starting for the war, his armour brightly shining; and the next day might see him as a fisherman, sitting beside a stream, his rod in hand, his basket full of fish. Even as an aged

crone did Vertumnus appear before Pomona; but it was as a youth, a noble, blooming youth, that he won the heart of the goddess. In the busy Vicus Tuscus this statue of the changeful god stood for many years, seeming to say to the ever varying multitudes, passing and repassing beneath him: —

"Move on! Change on! I watch! — I guard! The time of buds, the time of fruit, the time of harvest, all are mine. Come! — Work! — Go! — the god of Change is here, and over your welfare ever watches — guards!"

And it was a motley throng indeed over which the god Vertumnus watched, for the Vicus Tuscus was a crowded, business street, and one of no fair fame. Perfumers, spice dealers, silk merchants, there had shops, and thus those that came to buy were among the idler and gayer of Rome's citizens.

On the upper side of the Basilica Julia, another street enters the Forum and joins the Sacra Via. This is the Vicus Jugarius, at whose beginning once stood the altar of Juno Juga. Now by "jugum," the Romans meant a "yoke," — something that bound two things together, — and thus

Juno, the wife of Jupiter and the queen of heaven, was often worshipped as Juno Juga — the goddess of Marriage.

It happened at one time that, as a great storm was over the city of Rome, the lightning struck the Temple of Juno on the Aventine Hill. This was considered as a sign of the goddess's displeasure, and accordingly two sacrifices were ordered in her honour. One of these solemn processions, which were parts of the holy rites, passed along the Vicus Jugarius, on its way to the Temple. At the head were led two white heifers, about whose horns were twisted ribbons and garlands of flowers; for only white animals were sacrificed to the heavenly deities, and such as were chosen for this honour were not only gayly bedecked, but were led with a loose rope, that they should appear to go as willing offerings. Following the heifers were reverently carried two images of Juno; then came twenty-seven fair maidens in long, white robes, their clear, sweet voices rising and falling in a hymn to the queen of heaven. Behind these maidens walked ten magistrates, crowned with leaves of laurel and wearing purple robes. In the Forum the procession paused, and

a long cord was given to the damsels, each of whom rested her hand upon it, and, thus held together by that which was a symbol of their common purpose, the young girls, beating time with their feet to the music of the hymn they sang, went on with the procession as it passed up the hill to Juno's temple. And men remembered long the sight of these fair maidens; and the story of that solemn progress through the Vicus Jugarius was told and retold for many years.

Something there was, however, concerning this street that men remembered much longer, and of which they always spoke with bated breath — it was the recollection of the horrible sights that were once seen on the Lacus Servilius.

For the Lacus Servilius was a fountain that stood in the Vicus Jugarius, at its entrance into the Forum, and during the terrible days of Sulla's misrule the heads of many senators were placed thereon. With cunning wisdom did Sulla cause these grewsome trophies of his power to meet the eyes of the Romans even as they approached the Forum, and upon the immediate, trembling obedience of the people his great and unquestioned might became established.

But the street full of the greatest memories —
the street, not only of the Forum, but of Rome —
was the Sacra Via. From the very beginning,
when this road was but a pathway between the
Romans and the Sabines, the Sacra Via was
trodden by those whose deeds and misdeeds made
Rome's history. Over its winding way through
the Forum passed the solemn processions of the
gods; along it moved the mournful followers of
the dead; through it rode the triumphal trains of
victors; and always busy feet wore out its stones,
as the people of Rome went hither and thither
about the business and pleasure of their daily
life.

It was in the month of September in every
year that the famous Ludi Romani, or games of
Rome, were celebrated in honour of great Jupiter,
god of the gods, who, from his temple on the Cap-
itoline Hill, ever guarded the welfare of the State.
There, from the Capitol, a solemn and magnifi-
cent procession started on its way to the Circus
Maximus, the great arena formed by King Tar-
quin the Elder on part of that land which he had
made firm by his wonderful drains. And here,
when festivals were held, races and contests of

various sorts took place; and the rumble of
chariot-wheels, the cries of wild beasts, the clang-
ing of armour, mingled with the excited and
delighted laughter of thousands of spectators.
After sacrifices in Jupiter's temple, the long train
of the Ludi Romani wound down the hill into
the Forum, and there, having turned into the
Sacra Via, and gone along that road until it
reached the Vicus Tuscus, it passed out and went
on to the Circus.

The hearts of all old soldiers beat fast with
pride as they saw, coming at the head of this
bright company, the young sons of the knights
and other veterans of the army, each youth riding
a fine steed or walking on foot according to his
father's rank. And strangers, also looking on,
marked well the rich promise of Rome's future
heroes, and departing, wonderingly told their
countrymen of this vision of Roman valour that
they had seen. Next to the noble youths came
charioteers, guiding some four, some two, fiery
horses, all panting for the race; and wild huzzas
broke from the crowd as combatants and dancers
closely followed on. Among these dancers, who
advanced in groups, and who were accompanied

233

by players of the flute and by those that made music from ivory lyres, there came, first men, then youths, then boys. All these dancers wore vests of scarlet; from their brazen belts hung swords, while in their right hands they held short spears. The men wore also helmets of brass, gayly adorned with waving plumes; and each swayed with happy grace as he slowly moved along.

Then came dancers of another sort, men that wore hairy vests of goatskins or bright coats of flowers, and that bore, standing upright on their heads, the manes of different animals. For these dancers appeared as fauns, — followers of Faunus, god of the Woodland, — whose wild frolics in the moonlight make the forests echo and reëcho with their unbounded glee. Quietly following these capering fauns there walked many musicians, to the measure of whose strains the incense carriers coming after, softly swung their fragrant censers. And in this light haze of perfumed smoke, there shone holy objects of silver or of gold that had been given as offerings to the gods by the citizens and the State, and that were now carried in honour of the deities. For just behind, there ap-

234

peared the images of the gods themselves, borne
on men's shoulders or carefully drawn in small
chariots, whose traces the noblest citizens deemed
it an honour to hold. In this manner the pro-
cession of the Ludi Romani moved along the
Sacra Via, and through the city escorted the
gods of Rome.

As the Romans worshipped many gods, so they
celebrated many festivals, and again and again
solemn companies, such as those of the Ludi
Romani, were seen upon the Sacra Via. Like
all people of all lands, the Romans found much
pleasure in watching such bright array, and at
the sound of coming music the crowds would
quickly gather along this famous street, for it was
well known that all important processions must
pass that way. And perhaps the throngs were
never greater than at the burial of some noble
Roman, whose power and whose wealth promised
them a great oration and a grand funeral train.
For it was the custom to carry the body of a
high-born citizen into the Forum, where it was
placed before the Rostra, upon which stood some
near relative who spoke in praise of the great
deeds and of the many virtues of the dead. And

the richer and the mightier the man the more splendid his procession, the more eloquent his oration.

Thus the funeral of the Emperor Augustus was one long remembered in Rome. The people, having been summoned by the heralds, came to the Forum by the first light of day, and stationing themselves on the Sacra Via and along the rest of the procession's path, they waited for the coming of the solemn train. It was yet early morning when the body of Augustus was borne forth on its way to the Rostra, whereon Tiberius, his adopted son, was to speak the funeral oration. The corpse of the Emperor was placed upon a bier of ivory and gold, and covered with cloths of purple, woven and interwoven with golden threads; but only the images of Augustus were shown to the sorrowing multitudes. Of these images there were three: one brought from the palace on the Palatine Hill, where he had lived as Emperor; another borne from the Curia, where he had governed as supreme ruler; and yet another driven in a chariot, wherein he had ridden as victor. With the procession walked torch bearers and incense carriers, and at its head

advanced trumpeters and buglers, whose instruments gave forth grave, dismal sounds. Behind these musicians slowly came certain senators of Rome, bearing upon their shoulders the bier of Augustus, lovingly called by his people the "Father of his Country." In sign of their deep mourning, these senators wore no marks of office, but appeared in plain togas without stripes, and with no rings upon their fingers. Then, each in a chariot, there followed many men that appeared as the distinguished ancestors of the Emperor. For when a Roman noble died, a waxen image was taken of his face, and this was reverently hung in the atrium of his home, among those of the other members of his house. At the burial of any of his name, these masks were taken down, and men were hired to appear as the living images of his family's famous ancestors. Bearing these masks upon their faces, wearing the exact clothes and marks of office due the rank of those they represented, these men were wont to ride in the funeral procession accompanied by the number of lictors allowed their assumed stations. And all the lictors, including the twelve belonging to the Emperor, were dressed in black,

237

and marched in single file, their fasces held downward. Thus the older the family, the greater the train of ancestors; and those seen at the funeral of Augustus were very many indeed. However, the greatest of them all was not represented, for Julius Cæsar had been made a god, and so had no longer a place among mortals.

Next in this great procession were borne figures of Romans whose strength, whose valour, and whose wisdom, had been of value to the nation. From Romulus to the statesmen of Augustus's own day — all were there. And then were carried the images of those peoples whose lands this Emperor had conquered; as if to say, " The whole world mourns for thee, most mighty ruler."

In robes of sombre hue, the relatives and friends of Augustus now followed, their actions and their looks showing signs of greatest grief. And ending the procession came the noblest and most famous of Rome's citizens, proud indeed of the honour thus permitted them.

Before the Rostra the magnificent bier was set down, and about it were placed chairs for those that represented the ancestors of the Emperor.

238

Then Tiberius, mounting the platform, delivered a long oration in honour of Augustus; and a wonderful stillness fell throughout the Forum as the vast multitude strained forward to catch every word. When the last tribute had been paid, the last eloquent word spoken, the splendid, solemn procession formed once more, and the body of the Emperor was carried onward to his funeral pyre.

Very different from these silent, sombre multitudes, were the gay, happy crowds that flocked to the Forum whenever a great triumph was to be celebrated. For them all the world of Rome rejoiced, because the nation's enemies had been conquered, and the mighty general that had gained these victories rode in highest state to the Capitol, there to pay homage to the great god, Jupiter. Every one was in brightest, holiday attire; every side echoed with light jest and song, and everywhere many-hued ribbons and garlands floated in the breeze. The doors of all the temples were thrown wide open, and within, sweet flowers were placed before every shrine, while rare incense burned upon every altar. Eager people lined the Sacra Via from

end to end, particularly in the Forum, where the galleries of the basilicas, the Columna Mænia, the steps of the buildings, and many special scaffolds were all thronged to the very utmost.

Of the many days of splendour witnessed in Rome, one of the most magnificent was that on which the Emperor Vespasian and his son Titus triumphed together after their victories in Palestine. Here they had long besieged and finally captured the Holy City of Jerusalem, and so great had been their successes that the Senate had voted them separate triumphs; but these Vespasian had refused. So now there was to be a double triumph; and a motion like a long, slow wave, passed over the people as, at the sound of trumpets, each man moved forward the better to see the coming show.

Amidst cries of respectful salutation, first passed the senators and the higher magistrates of Rome, all in their richest robes and ornaments; and behind them the trumpeters sent forth gayest strains of martial music, to which from time to time the delighted people joined their voices. Then exclamations and cries of wonder were heard on all sides, as the spoils and

treasures taken by Vespasian and Titus were dis-
played to the admiring people. It was as if a
river of gold, of silver, of ivory, and of precious
stuffs, was rolling by. For carriers, clothed in
garments of purple and gold, wearing fine orna-
ments, and bearing laurel leaves upon their
heads, now passed in great numbers, each man
laden with articles of rarest value. There were
all kinds of fine embroideries, cunningly fash-
ioned objects of silver, wonderful carvings of
ivory, glittering gems in crowns of gold, and
costly images of the gods.

After all this splendour there came, with slow,
deliberate tread, the white oxen without spot or
blemish that were destined to be sacrificed to
Jupiter, and beside them walked white-robed
priests, accompanied by young boys, bearing
sacred vessels and instruments. And following
these appeared the human sacrifices; for at every
Roman triumph wretched captives were put to
death, that the vainglory of the victor might be
complete. Among these prisoners, all in finest
garments, came the chief enemy of Titus, Simon,
son of Gioras, and general of the Jewish army.
In chains, like the rest of the captives, this man

had also a rope around his neck, and as he trem-
blingly passed along, his proud spirit was crushed
by the sneers of the pitiless crowds, and the tor-
ments of his cruel guards. Close to the captives
marched the imperial lictors, holding, against
scarlet tunics, fasces without axes, but wreathed
with triumphant laurel.

And then came men bearing such marvellous
burdens that the people were astonished, not only
at the wonderful things they saw, but at the sight
of such heavy weights carried for so great a dis-
tance. For there, upon large platforms, many of
which were covered with carpets of gold, were
seen representations of the lands conquered by
the Emperor and his son; and not a few of these
models were three or four stories high. Great
ships were also borne before the amazed multitude;
but of all the spoils shown in this famous triumph,
the most noticed and applauded were the treas-
ures taken from the wonderful Temple of Jerusa-
lem. Stalwart men staggered under the weight
of a large table of solid gold, upon which the
priests had been wont to lay the sacred loaves of
bread; others carried the beautiful golden candle-
stick of seven branches, whose lamps had light-

ened the innermost portion of the Temple — the
Holy of Holies of the Jewish worship; and some
say that in this Roman triumph yet other carriers
exultingly showed the Table of the Law of the
conquered nation; but of this no man is sure.
However, although this last proof of greatness
may have been lacking, the triumph of Vespasian
and Titus was magnificent enough to satisfy the
most ambitious; and rejoicings over Rome's fallen
foes were expressed by men that now followed,
holding aloft glittering statues of Victory, all splen-
didly wrought in ivory and gold.

And now, in a round chariot, drawn by four
white horses, approached the Emperor himself,
closely followed in a like manner by Titus, his
son. Before them slowly walked priests, burning
incense, as to the gods, for during a triumph the
victors were thought to be none less than earthly
Jupiters — and, in truth, had they not protected
and even saved the State? So while in their
right hands Vespasian and Titus held boughs of
laurel, which showed their power to conquer
mortals, in their left they carried ivory sceptres
crowned with eagles — great Jupiter's sacred bird
— as a sign that their might exceeded that of

men and that they stood equal with the gods. Behind each of the royal conquerors, whose purple robes glistened with embroideries of gold, was placed a figure of Victory that held a crown of laurel above his head. Beneath both chariots tinkled tiny bells that warned off evil spirits, and there, also, hung images of Fascinus, god of Protection, who charms away all harm from those he guards. Thus arrayed and thus protected, the two victors passed through the city, and with them, mounted on a horse of surpassing beauty, rode Domitian, Vespasian's other son. Cheers rent the air as the three grandly proceeded on their way; nor did the joyous cries grow less when, coming directly after, were seen hundreds of Roman citizens that had been rescued from the enemy, or freed from slavery. Ending this superb spectacle of wealth and of power, marched the entire force of the foot-soldiers of the Roman army, singing loud, gay songs, and shouting again and again, "Io triumphe!" "Triumph! Triumph!"

At the foot of the Scalæ Gemoniæ, close by the Temple of Saturn, the Emperor paused, and, from the midst of the triumphal train, Simon, son of

Gioras, was dragged forth. Up those stairs of
terror he was led, and while the glittering, joyous
throng lingered in the Forum, he was strangled
to death in the depths of the loathsome Tullianum.
Whereupon, with still louder rejoicings, the mag-
nificent procession continued its way onward and
upward to Jupiter's temple, where the conquerors
laid their laurel wreaths in the lap of the Ruler of
the gods, thus offering him the homage of their
valour and of their glory.

These are some of the many stories that the
stones of the ancient Sacra Via tell; such were
some of the countless processions that went over
this famous road. No wonder, then, that its
name is known to all that have heard of Rome,
for her greatest and her humblest have passed
that way.

On the Sacra Via, near the remains of the
Rostra, there can be seen to-day the base of a
column that the Romans called the Umbilicus,
and that they proudly believed marked the centre
of the world. Standing on this spot, the whole
history of Rome might have been read as from an
open scroll, for there were seen the signs of her
struggles, of her losses, and of her successes; of

her religion, of her government, and of her art. The Forum, the great Record-book of the Nation, lay widespread for all to read, and, by its buildings and monuments, its columns and statues, its roads and gateways, told the wonderful story of the ancient Romans and of the mighty city wherein they dwelt.

INDEX

INDEX

Games, religious, 5.
Roman, see Ludi Romani.
Gauls, 36, 47, 75, 109, 165, 167, 198;
coming of, 35, 107; destruction of Rome by, 37, 108;
lay siege to citadel, 108;
slaughter by, 107.
Germanicus, 55, 56.
Geta, 63.
Gladiators, 5, 6, 45, 134.
Glaucia, 126.
"Gold, sacred," the, see Ærarium
Sanctius.
Golden Age, 67, 68, 76, 82.
Golden Milestone, see Milliarium
Aureum.
Gracchus, Gaius, 201.
Gracchus, Tiberius, 201.
Græcostasis, 112, 115; description
of, 40, 111.
Grappling-irons, invented by Duilius, 117–118.
Gratian, 138.
Greece, 68, 71, 104, 112, 113, 131.

Heliogabalus, story of entrance into
Penetralia by, 178.
Hercules, 172; erects altar to Saturn, 68.
Hermadorus, statue to, 105.
Hieron, defeated by Messala, 114.
Horace, 54.
Horatii, the, description of battle
with Curiatii, 86–88; sister
of, 88.
Hostilius, Tullus, 85; builds Curia,
21, 85.

Icilius, 32.
Ilus, 155.
Italy, 68, 73, 116, 132, 156, 176.

Janiculum Hill, 101-102, 166.
Janus, 17, 73; altar to, 17, 18, 20-
21; temple of, 21.
Judgment-seat, see Tribunal.
Juno Juga, 229, 230.
Jupiter, 15, 17, 20, 27, 90, 155, 174,
184, 187, 230, 239, 241; Temple of, 38, 196, 215, 222, 233,
245.
Juturna, the fountain, 183.
the nymph, 182.

Lacedæmon, 131.
Lacus Curtius, 16, 38; altar on,
54; custom at, 54; trees at,
54.
Lacus Servilius, 231.
Lævinus, 78, 79.
Latins, 115; conquered at Antium,
109; ships of, 110.
Laurel, in Regia, 153; in Temple
of Vesta, 152; sign of triumph, 185; story of, 151–
152.
Laurel trees, in front of Chapel of
Mars, 153, 170.
Laws, beginnings of, 17, 84; given
to civilized world, 140.
Agrarian, opposed by Bibulus,
193; proposed by Cæsar, 193.
Oppian, matrons demand repeal
of, 120; repeal of, 122.
Republican, 98.
Twelve Tables of, 105.
Leda, 185.
Lentulus, 203, 205, 206.
Lictors, 130, 160, 237; duties of,
100-101.
Livia, 207.
Lotus tree, in grove of Vesta, 147,
148.

251

INDEX

INDEX

Pallas, daughter of Triton, 155, 156.
Pallas (Minerva), 156.
Pallas, son of Evander, 12, 13, 14.
Patricians, at peace with Plebeians, 200; Curia, the stronghold of, 110; meaning of, 28, 99; refuse Plebeians a consul, 198–199.
Paul, St., 60.
Penetralia, 178; cleaning of, 159; contents of, 153–154, 157; entered by Metellus, 168; meaning of, 154, 181; open during Vestalia, 154, 158.
Peneus, 152.
People, character of, 55; compulsory work of, 26; confidence in Treasury of, 76; early, 10, 11; self-denials of, for replenishment of Treasury, 76–79; threat of, 37; uprising of, 32.
Perseus, 187, 188.
Peter, St., 60; church of, 179; in Tullianum, 61.
Philip of Macedon, 77.
Pila Horatia, 89, 99.
Piso, statues of, 57; story of, 56–57.
Plebeians, a consul demanded by, 198; a poor debtor, 29; at peace with Patricians, 200; meaning of, 28, 99; meeting-place of, 110; special magistrates given to, 105; wrongs of, 28–29.
Pliny, story of case tried by, 216–217.
Polycrates, story of ring of, 208–210.
Pomona, loved by Vertumnus, 228.
Pons Sublicius, 166; description of, 102.

Pontifex Maximus, 146, 147, 152, 154, 160, 161, 164, 168, 171, 173, 176; duties of, 145.
Pontus, 131.
Porsenna, 102, 226, 227; Rome besieged by, 101; statue of, 104.
Postumia, the Vestal, story of, 164.
Postumius, 186, 196.
Prætextatus, Vettius Agorius, 177.
Prison, see Tullianum.
Probianus, Vettius, 218.
Processions, 230.
 funeral, 235–236.
 of Ludi Romani, 233–235.
 triumphal, 239–240; of Vespasian and Titus, 240–245.
Proscription, Sulla's, 128–129.
Pulcher, Claudius, story of triumph of, 170–171.
Pythagoras, statue of, 112.

Quæstors, 73, 79; duty of, 72; "sacred gold" in charge of, 75.
Quintus, Cicero, see Cicero Quintus.

Rabonius, 191, 192.
Records, in Tabularium, 47.
Regia, 27, 47, 50, 62, 173, 222; adorned with laurel, 153; building of, 20, 145; burning of, 167, 169, 170, 175; chapels in, 153; Clodius's intrusion into, 171–172; given to Vestals, 176; meetings in, 153; records kept in, 153; rebuildings of, 170, 175; ruins of, 179; use made of marble of, 179.
Regifugium, description of, 90.

253

INDEX

INDEX

CPSIA information can be obtained at www.ICGtesting.com
Printed in the USA
270400BV00007B/34/P